MW00576313

Action

Central Problems of Philosophy
Series Editor: John Shand

This series of books presents concise, clear, and rigorous analyses of the core problems that preoccupy philosophers across all approaches to the discipline. Each book encapsulates the essential arguments and debates, providing an authoritative guide to the subject while also introducing original perspectives. This series of books by an international team of authors aims to cover those fundamental topics that, taken together, constitute the full breadth of philosophy.

Published titles

Forthcoming titles

Action

Rowland Stout

McGill-Queen's University Press
Montreal & Kingston • Ithaca

© Rowland Stout 2005

ISBN 0-7735-3048-7 (bound)
ISBN 0-7735-3049-5 (paper)

Legal deposit fourth quarter 2005
Bibliothèque nationale du Québec

This book is copyright under the Berne Convention.
No reproduction without permission.
All rights reserved.

Published simultaneously outside North America
by Acumen Publishing Limited

McGill-Queen's University Press acknowledges the financial support of
the Government of Canada through the Book Publishing Development
Program (BPIDP) for its activities.

Library and Archives Canada Cataloguing in Publication

Stout, Rowland
 Action / by Rowland Stout.

(Central problems of philosophy)
Includes bibliographical references and index.
ISBN 0-7735-3048-7 (bound).—ISBN 0-7735-3049-5 (pbk.)

 1. Act (Philosophy) I. Title. II. Series.

B105.A35S76 2005 128'.4 C2005-904159-5

Designed and typeset by Kate Williams, Swansea.
Printed and bound by Cromwell Press, Trowbridge.

Contents

Acknowledgements

I would like to thank Al Mele and an anonymous referee for Acumen for very helpful comments on a penultimate draft. I also want to acknowledge the help provided by University College Dublin in providing me with a semester's research leave at a crucial point in the process of writing the book. The book developed out of several years of teaching the philosophy of action at undergraduate and postgraduate levels as well as supervising research theses at the University of Oxford, University of Manchester, University College Dublin and Trinity College Dublin. I am indebted to all my students on all these courses for their sceptical approach to everything I have had to say. I dedicate the book to Rebecca for freedom, causation and rationality.

Introduction: inward-looking and outward-looking
1 approaches to agency

Being an agent

At the very heart of our conception of what it is to be a person is the idea that we (as people) are both *subjects* and *agents*. Being subjects of experience, we are conscious of ourselves and our world. We are receptive to the way things are, and have perceptual and emotional experiences as part of that receptivity. But we also act on our world. We change it in the light of our reasons. We are agents as well as subjects: active as well as passive. Action and experience, agency and consciousness, hand in hand make up our very nature.

The properties of being an agent or a subject come in varying degrees. At the most minimal level we might think of the sun as an *agent* in the process of warming up a stone, or of a planet as *subject* to the force of gravity. And at the other extreme we have full-blown agency and consciousness. A person is the full-blown agent of an intentional achievement when they write a book. And they are the full-blown subject of conscious experience when they watch the sun set, attending to every shifting pattern of colour in the clouds.

There are intermediate cases. A sunflower turns to face the rising sun. This is an action in some sense. And although the behaviour of the sunflower is not deliberate, it is not accidental either. It is directed to the goal of its bloom facing the rising sun.[1] In some sense the sunflower registers the direction of the sun. But it is not consciously aware of the sun. So in a limited sense it is both subject and agent, but in a more full-blown sense it is neither. The same goes for simple animals. The snail acts when it pulls in its horns in response to some-one touching it; and it is in a way aware of the finger touching its

horns when it acts like this. But it is only in a very weak sense that it can be said to act and be aware. The snail's horns' retracting when touched is like your pupils' contracting in bright light. It is automatic behaviour: not really action at all. Your registering of the bright light is not really awareness of it and nor is the snail's registering of the pressure of someone's fingers touching its horns.

With more and more complex animals the issue becomes more difficult to assess for both intentional agency and conscious awareness. Is the cow really consciously aware of its environment, and is it really able to act intentionally on its environment by eating grass for instance? I think these questions go hand in hand, and also hand in hand with the question of whether the cow is a person in some sense. Even though it sounds absurd initially, there is a weak sense in which a cow may be said to be a person. We may refer to the cow using a personal pronoun and attribute a personality to it: "She is being skittish today". And in this vein we talk about what the cow sees, feels and does. But there is also a full-blown sense of being a person in which a cow is not a person. In just this full-blown way, the cow is neither really an agent nor really a subject either. At least you probably have to believe this in order to swallow beef without gagging on it.

As an infant grows it develops its nature as a person, and its agency and consciousness develop at the same time. Initially it may be said to be aware of the face of its parents, but only in rather a weak sense. And equally it may be said to act when it cries for food for instance. But its crying could not be said to be deliberate or intentional. The infant's picture of the world then develops in tandem with its ability to achieve things in the world. It perceives the world as such only when responses to perceptual cues are integrated with each other and with adaptive behaviour patterns such as grasping and sucking.[2] Pretty soon it is a full-blown agent and subject.

The philosophy of action is concerned with the nature of agency: what it is to be a full-blown agent and what it is to realize one's agency in acting deliberately on things. It is important in the philosophy of action to consider the weaker sense of agency too. Understanding what it is for one thing to act on another – for example the sun to warm the rock – is necessary in order to establish the general category in which we can make sense of real agency in which a person deliberately acts on their environment. Full-blown agency is a special case of agency in the weak sense.

What counts as intentional action?

Being an agent is being something that acts, something that does actions. This means that in the philosophy of action we are dealing with two types of entities: agents and actions. But it is important to remember that actions do not have existence independently of their agents. An action is an agent doing something, and as such essentially involves the agent. Understanding action is understanding what it is for an agent to act.

The question of what it is to be a full-blown agent needs to be answered in tandem with the question of what is it for someone to act in a full-blown way. And this is usually taken to be the same as asking what it is for someone to act *intentionally*. Characterizing intentional action and distinguishing it from lesser sorts of action or activity are the central goals of the philosophy of action.

There are plenty of things going on with our bodies that are not part of our acting intentionally. Our eyes dilate in the dark or in response to sexual arousal, our skin comes out in goose-pimples, our hearts beat, and so on. Also there are plenty of things that change in the world outside our bodies but are related to us in other ways that do not count as our actions or at least our intentional actions. When your sibling has a baby you might become an uncle or an aunt. Perhaps we could invent the verb *to uncle* or *to aunt* to describe this; so I uncled a few years ago. But this is not something I *did intentionally*. Likewise if accidentally I spill a drink or squash a microbe or surprise my friend when they see me at a distance cycling down a hill, I am not doing these things intentionally.

These are relatively clear-cut cases. There are also aspects of human activity that are more difficult to characterize as clearly cases of intentional action or clearly not such cases. Breathing is automatic behaviour that should on the face of it be categorized with the beating of our hearts. It is not something we do intentionally but is something that happens inside our bodies. However, *grammatically* it seems to belong with intentional action and not with bodily activity. Breathing is something we do; beating our hearts is not something we do. Now this grammatical point need not mean anything. Sweating is also something that we do. But at the same time it is something our skin does as part of our autonomic nervous system. However breathing is a more difficult example because it is something that may be brought under conscious intentional control.

Although breathing is normally not intentional, sometimes it is. For example, you might hold your breath and then decide to take a breath at a certain moment.

Sometimes too it is very difficult to say one way or the other. Suppose you are following some relaxation techniques, concentrating on your breathing, making sure you take deep slow breaths and exhaling slowly too. What seems to be going on here is that an entirely automatic bodily process of breathing is going on but being moderated by some conscious intervention. It is not so much that the action of breathing is intentional but that the slow and relaxed quality of the breathing is intentional. And then when you stop concentrating on your breathing it continues to be slow and relaxed, at least for a while. You have initiated a way of behaving that continues under its own momentum. Much of our behaviour is like this. When we walk, the right knee bends and the left foot moves forwards in a controlled way, but we do not have to think about it. Indeed it is better not to think about these movements as they happen or else you start to limp. Should such automatic behaviour count as intentional action?

I am inclined to think that it should count as intentional, for so much of our behaviour is in this category. Having got out of bed in the morning, you may be on autopilot for a while. And even when you make a conscious decision to do something – for example to have some toast and jam for breakfast – the achievement of that goal may be largely habituated and automatic. Most of what you are doing is done without any thought. If we ruled all this behaviour out of the category of intentional action, we might not be left with very much.

There are stranger problematic cases too. Is acting under hypnosis acting intentionally? In the comic caricature of hypnosis, acting under hypnosis is acting like a zombie under an inescapable compulsion, and it does not look like intentional action. But in reality hypnosis is not like that. You may have been given the suggestion under deep hypnosis that when you have a cigarette in your fingers you will break it in half and throw it away. This suggestion would have no force if you were not party to it in some deep way; you may indeed have given *yourself* the suggestion during autohypnosis. When you break the cigarette, it is because you have decided to do that, and you feel proud of yourself for doing it.

Even compulsive behaviour usually counts as intentional action. Faced with the chocolate bar the compulsive eater will decide to eat it, perhaps hating themselves for doing so. Even if they do not think about it as they do it, and even if they describe the compulsion as overwhelming, it is still *their* action; it is something they must own and take responsibility for. If they were sitting next to someone who, as they knew, needed to eat that chocolate bar or die of starvation, they would not eat it; or if they did then they would have to accept their responsibility for that person's starvation.

A more extreme case of compulsive behaviour is that of someone with Tourette's syndrome. This is a neurological condition probably caused by some failure to process neurotransmitters properly that starts in childhood and results in the sufferer producing involuntary tics, both physical and verbal. These tics and jerks are not completely uncontrollable since the sufferer may with a great effort of will resist the compulsion to produce them, but in that case these tics will certainly come back later and in a more extreme form when the sufferer stops trying to stop them.

One aspect of this condition that occurs in perhaps 30 per cent of all Tourette's sufferers is coprolalia: the compulsive utterance of obscenities. At the most inappropriate times the sufferer will utter the foulest words. The medical profession seems clear that the tics and obscene language and gestures are not intentional actions. The sufferer is often very distressed that they are producing them. And although a sufferer may control them for a short time, this is like controlling a sneeze or stopping oneself blinking; it is likely to come back again and not be controllable. When asked why they just ate a bar of chocolate the compulsive eater may hate the question and not want to answer it; but they have to acknowledge that it is a reasonable question. But the Tourette's sufferer may say that it would be somehow inappropriate to ask why they did that tic. It does not make sense to ask why they did it, since in that sense they did not really *do* it; it was just something that happened, like blinking.

How to characterize intentional action

There are two places to look for an answer to the question of how to characterize intentional action. And these determine the two main approaches to the philosophy of action. One place to look for a

defining characteristic is inwards to the human mind. Is there some structure of psychological entities, states or events whose presence means that the person is acting intentionally? For example, should we try to identify some internal mental *act* – an act of will – that marks out what then occurs as an intentional action? Or perhaps there is a *state* of mind – a belief, piece of knowledge, desire or intention – that must be present in the background, driving the behaviour, if that behaviour is to count as intentional.

The other place to look is outwards to the way the behaviour is related to the agent's environment. Intentional action responds to what is required of the agent in different circumstances. It is sensitive to the environment. And this sensitivity is mediated in some way by rationality. What we do adapts to what we have reason to do. Intentional action is embedded in a system of reasons, subject to questions about justification, and sensitive to what should be done. Is this what marks it out as intentional action?

I think it is plausible that when we look inwards to the mental precursors of action we find something characteristic of intentional agency, and that when we look outwards to the sensitivity of action to what the environment gives us reason to do we also find something characteristic of intentional agency. The first of these is fairly clear. When you act intentionally, you must *intend* to act; and this means you must be in the mental state of intending.[3] Also you must have certain beliefs: for example, that what you are doing is not impossible. And perhaps you must also know what you are doing; you must have some knowledge or consciousness of your own agency.

Many philosophers approaching the question of agency start by looking inwards. It may not seem obvious that we should look outwards at all to try to understand it. But action is the transformation of the world in the light of reasons, and reasons are not entirely internal things. When you think about what to do, you do not generally consider your own mental states; you think about what should be done given the external circumstances. To this extent you adapt your behaviour to reason; and reasons are provided (at least partially) by the world outside.[4] Similarly, when you consider someone else's agency you try to make sense of their behaviour in the context of the world they occupy as well as in the context of their psychology. Only by seeing what they do as responsive to what they *should* do in some sense can you see it as manifesting true agency.

And what they should do is not determined just by looking inside their mind. So looking outwards to the rational sensitivity of action to its environment also reveals what is characteristic of real agency.

Applying the inwards-looking approach to the Tourette's sufferer, we could ask them what was going on in their mind when they uttered some expletive. They might say that nothing at all was going on; they did not want to utter the expletive and did not intend to. And this would make us think that it was not an intentional action. But we could also apply the outwards-looking approach and observe that this utterance had no rational connection with anything else they were doing. And this would be more than seeing that what they did was a sort of mistake, since unlike a mistake the utterance is not subject to correction. The Tourette's sufferer does not utter the expletive for a reason – good or bad – or even for *no* reason. It is simply inappropriate to apply the demand for reasons to this behaviour.

Volitionism

In his First Meditation Descartes considers the possibility of an evil demon deceiving us into thinking that there is any physical (i.e. spatial) world at all when all there is really is a mental (non-spatial) world. In this imaginary scenario the evil demon presents our minds with the very appearances that we are in fact aware of, but in this case without there being any reality behind them. Receiving these appearances into our mind is an entirely passive process, according to Descartes. Whether it is the world acting on us or an evil demon acting on us, we as agents have nothing to do with it.

But the evil demon cannot get any further into our minds than that. Although it can deposit false *appearances* into our mind, it cannot mess with our *thoughts*. It cannot simply deposit the thought that I am a thinking thing. Coming up with that thought must be something I do, which is why in this case its truth is not itself subject to reasonable doubt. So there is room in Descartes's model for the agent to be in control of what goes on inside their mind. This means that in some very limited way agency is essential to our nature as conscious beings. But the agency that Descartes takes to be essential is not our acting in the world but our acting in our minds: acting *mentally*.

For Descartes, acting in the world consists in acting mentally by committing an act of will, and this then causing the body to move and the world to change.

> [O]ur merely willing to walk has the consequence that our legs move and we walk. (*Passions of the Soul*: section 18)

> And the activity of the soul consists entirely in the fact that simply by willing something it brings it about that the little gland to which it is closely joined moves in the manner required to produce the effect corresponding to the volition. (*Passions of the Soul*: section 42)

This weird picture of action, nowadays called *volitionism*, emerges very naturally from Descartes's conception of the separation between mind and body. Given this separation your agency must be taken to be completely contained in your mind. Your body's moving and making the world change so that the intended goal gets achieved is all happening outside your mind and outside the scope of your direct agency. You act in your mind and then the world responds.

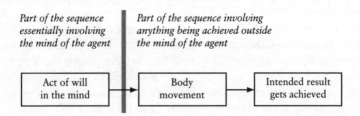

Part of the sequence essentially involving the mind of the agent *Part of the sequence involving anything being achieved outside the mind of the agent*

| Act of will in the mind | → | Body movement | → | Intended result gets achieved |

Many aspects of Descartes's theory are rejected by modern-day philosophers. A bit of anatomy has taught us that the pineal gland does not jiggle around as a result of our acts of will. Efferent nerves (the ones that send messages to muscles) are coming from all over the brain. Most philosophers of mind now reject Descartes's metaphysical dualism in which the mind is a different substance from the brain. And most (although by no means all) philosophers of action reject the idea that in order to act you must commit a *prior* mental act of willing before the body starts moving. Walking is not a matter of willing that your legs move and then waiting for them to go on to move.

Indeed this idea that every intentional action requires a separate mental action leads to an infinite regress. This was one of Gilbert Ryle's arguments in his powerful attack on Cartesian volitionism (1949: 67). Assuming that the separate mental action is itself intentional, then it too requires a separate mental action: the action of willing that you will your legs to move. And this requires another mental action, and so on *ad infinitum*. For every intentional action there must be an infinite number of separate mental acts, which is absurd.

The regress would be mitigated if the mental act of volition was not taken to be separate from the action but actually *constituted* the action. According to this idea, walking just is willing to walk. Assuming that willing to walk is itself an intentional action – an act of will – then, according to volitionism, you must at the same time will that you will to walk, and so on *ad infinitum*. However, since your willing that you will that you will … that you walk just is your action of walking, there is no infinite multiplication of actions. There is only an infinite multiplication of descriptions of your action; what you do can be described as an act of willing that you walk or an act of willing that you will that you walk, and so on. But everything can be described in indefinitely many different ways. That is not a *vicious* regress; it is a perfectly benign one.

Given Descartes's separation of mind and material world, however, this type of volitionism in which the action is identified with an act of will has the unpalatable consequence that walking does not happen in the material world. It would be the same act of walking if you had no legs or indeed had no body at all (although in such a situation it would not be *described* as an act of walking). This means that the act itself is nothing more than a mental event. The idea of acting essentially involving getting things done in the world is lost.

If we had a world-involving conception of the mind, this unpalatable consequence of this kind of volitionism might be avoided. Walking might be taken to be something that is mental – a mental action like willing to walk or trying to walk – while at the same time it is regarded as taking place in the material world. Your legs moving might be part of this mental act. Of course, this is to use the notion of the mind and the mental in a very different way from that employed by philosophers from Descartes onwards.[5] It is to deny that a genuinely inward-looking approach makes sense at all.

The infinite regress may also be avoided by denying that the mental part of agency is itself an intentional *action*. We might try to find the essence of agency by looking inwards only, but think that we find it, not in some act of the mind, but in some *event* or *state* of mind: for example an event of deciding or a state of intending, desiring or knowing. Not being an intentional action, this state or event would not require a further mental state or event.

But, although this avoids some of the absurdity of Descartes's volitionism, the central difficulty remains in some form. The main thing that makes Descartes's volitionism such a weird theory is that the part of action that involves things being made to happen in the world occurs outside of the person's agency. If the process of making things happen in the world is divided into two sections – a mental process starting with the agent's act of will and a physical process finishing in something being achieved in the world – it is inevitable that agency is limited to the first section. This is the bit where the agent is essentially involved.

By separating mind from body, Descartes has separated an agent from their achievement. First the agent does their stuff, although nothing actually happens outside the mind. Then as a result things outside the mind change, but these changes do not themselves essentially involve the agent. In the alternative non-volitionist picture, it is a mental event or state rather than an act of will that causes the body to move and the world outside to change so that the intended result is achieved. But it is still the case that what is essential to the agent's agency – some aspect of their mind – is separated from their making something happen in the world, just as in the weirder Cartesian volitionism.

The proponent of the inward-looking approach may say that what is essential for agency is not just the existence of some special state of mind, but that such a special state of mind is *causing* something to be achieved. So agency as a whole is not to be separated from achieving things after all. But it is still the case in this account that the *mental* aspect of agency is separated from an agent's achieving things. And this mental aspect must be that part of agency that is essential from the agent's point of view.

Now it is fair to say that many philosophers of action do not think that there is any problem with separating the essential part of agency that belongs to the agent's mind from the process of achieving

anything. And certainly the dominant approach to the philosophy of action is to look inwards in trying to find the essence of agency. But I think it is worth exploring an alternative approach that may allow action to be world-involving, at the same time keeping the core aspect of agency together with the process of achieving things. This alternative approach would take the essence of agency itself to be world-involving. So, while I shall consider the inward-looking approach in this book, I want at the same time to develop and examine an outward-looking approach that takes the essence of agency to consist in the agent being bound up in rational sensitivity to their environment.

Looking outwards to find agency

The inward-looking approach might be described as a top-down approach. It is an attempt to understand agency in terms of high-level mental states. As such it does not directly provide a way to understand less full-blown forms of agency: the action of animals, robots and so on. Within this approach such agency would be best understood as involving behaviour caused by an internal state of the animal or robot that is in relevant respects *like* the internal state characterizing full-blown agency. This internal state would be like our high-level internal states in virtue of being an internal representation but unlike them in not being conscious or perhaps in lacking some other high-level feature of the mind.

The top down approach has characterized the attempts of Artificial Intelligence for the past forty years. The idea has been that we should be able to construct intelligent goal-directed behaviour in a system by furnishing it with internal representations of the environment and of its goals and giving it the logical power to work out what to do given these. Such an approach has struggled to make much progress.

An alternative model of Artificial Intelligence that has emerged in the past twenty years is called *connectionism*. It is based on the idea that we can construct systems of connected nodes – neural networks – that can change the weighting of connections between these nodes depending on success or failure of the whole system in performing some task. The whole network adapts to its repeated successes and failures in performing the task, getting more and more reliable at performing it. When it has become very reliable we may attribute to

it a representation of the environment it faces when doing the task as well as of its goals in the task. But these representations are not programmed into the system explicitly; they *emerge* as features of the system when it has developed the capacity to perform the required tasks.

This approach may be described as bottom-up. A big success of the approach would be to model the behaviour of a snail for example. The long-term aim would then be to work up from this to modelling full-blown agency. In this approach the first task of the programmer is to get the system to solve tasks. And only after that – and as a result of that – is the system endowed with internal representational states.

The first thing that is achieved in this approach is the adaptability of a system to the requirements of its environment. And this is characteristic of the outward-looking approach to agency. Rather than looking for agency in the internal mental states and acts of the agent, this approach looks for agency in some aspect of the agent's relationship with the world. In particular it looks for agency in the agent's ability to adapt its behaviour to what its environment requires of it for certain goals to be achieved.

For full-blown agency this relationship must be more complicated. One idea that I shall explore in detail is that the behaviour of a full-blown agent must adapt to *rational* requirements. The behaviour that constitutes full-blown agency must adapt to what *should* be done or what it is *rational* to do in the circumstances. A full-blown agent is essentially a rational agent.

Outline

In the next two chapters I look at this idea that rationality is essential to agency. In Chapter 2 I consider the powerful historical tradition working through both Aristotle and Kant according to which agency essentially involves practical rationality. Is it right to say that full-blown agency must be embedded somehow in rationality? And what is rationality anyway?

In Chapter 3 I look at the question of whether rationality should be understood in terms of having appropriate mental states. If so then this apparently outward-looking approach turns back into an inward-looking approach. However there are some good arguments

to suggest that practical rationality is not best understood in terms of the rationality of having and responding to internal mental states.

Assuming that it is right to think of agency as essentially involving rationality or reason, then in acting we are making things happen in the light of reason. In the phenomenon of action we see reason or reasons getting involved in the causal nexus of the universe. And this is really what is so exciting about the philosophy of action. For there is something fundamentally challenging about the idea of reason and causation coming together. It is so challenging that many philosophers have denied it altogether and tried to understand the role of reason in action in non-causal terms. Practical reason concerns the rightness and wrongness of behaviour and it is usually assumed that such things do not figure in causal laws and have no place in causal explanations. In Chapter 4 I ask whether reason and causation do come together in action.

Instead of denying altogether that reason and causation come together in action, philosophers who take what I have described as an inward-looking approach have argued that reason gets internalized in an agent's mind and then can cause behaviour. The idea here is that the causal role of reason in action is taken by the agent's psychological states. The standard version of this theory – known as the causal theory of action – asserts that what characterizes intentional action is the agent's intentions or perhaps their beliefs and desires causing their behaviour in the appropriate way. In Chapter 5 I assess this sort of theory.

In Chapter 6 I look at a classic difficulty for such a causal theory of action: the problem of deviant causal chains. The problem here is that the right sort of thing might cause an agent's behaviour, but in the wrong sort of way; and when this happens it is not correct to describe the agent as acting intentionally. The challenge then is to specify not just the causes that characterize intentional action but the *way* these causes cause the behaviour. With this in mind I outline an Aristotelian approach to causal processes that seems to meet this challenge.

In Chapter 7 I consider the intentions with which one acts. What sorts of things are they and in what sense are they essential to intentional agency? Can the intentions with which we act be understood independently of understanding what it is to act intentionally? Do they have some existence outside of the scope of intentional action?

To answer these questions I look at the distinction between an unintentional but foreseen consequence of one's action and an intentional result of one's action, and then at the question of whether it is literally possible to share an intention with others.

In Chapter 8 I deal with prior intentions: the intentions one has before one acts. Can they be understood in the same way that we understand the intentions with which we act? I look at a very influential theory of what such intentions are proposed by Donald Davidson. His idea is that to intend to do something is to judge unconditionally that it is the most desirable thing to do. A problem faced by such an approach, and indeed any approach that links intentional action with rationality, is how to explain weakness of will. Weakness of will in this context is said to be exhibited when you judge one thing to be the best and most desirable thing to do but still do something else. Such a phenomenon seems all too common, but Davidson has to do a bit of work to make room for it in his account.

Finally, in Chapter 9 I look at some metaphysical issues concerning action. What sorts of things are actions? What can they be identified with? How long do they last and how far do they extend in space? Do actions exist in the world outside the body of an agent, or do they happen in the body, or perhaps in the mind?

One thing that I shall not discuss in any detail in this book is the problem of free will. The relationship between freedom and agency is a crucial one and questions about the nature of free will and its compatibility with a scientific worldview do properly belong to the philosophy of action. But these issues have attracted enough philosophical argument all by themselves to have become a self-enclosed area of enquiry. In this series of books the question of free will is addressed separately by Graham McFee (2000).

2 Acting for a reason

Two kinds of explanation

In 1957 Elizabeth Anscombe published a groundbreaking book in the philosophy of action called *Intention*. Partly inspired by Wittgenstein and partly inspired by Aristotle, she sought to provide an outward-looking account of action. She started off by asking the question: what distinguishes actions that are intentional from those that are not? Her answer was: "that they are the actions to which a certain sense of the question 'Why?' is given application; the sense is of course that in which the answer, if positive, gives a reason for acting" (1957: 9). Although Anscombe did not put it as bluntly as this, the idea is that what makes action stand out from other natural phenomena is that the explanation of what someone did in some weak sense *justifies* what they did at the same time.

Suppose you want to know why a certain liquid dissolved some salt. The explanation may include the fact that salt ionizes in such a liquid. This provides a reason of sorts. We do say that the reason why the liquid dissolved the salt is that the salt ionizes in such a liquid. But, of course, this is not a reason *for the liquid*; the liquid's action is not thereby justified.

Knowing the reason *why* the salt dissolved makes it intelligible to us. We understand why something happens when we know the causal explanation of its happening. And the reason why the salt dissolved forms part of its causal explanation. But there are different kinds of intelligibility. What I want to understand when I see someone waving a flag is a different kind of thing from what I want to understand when I see a liquid dissolving some salt. In both cases

I want to know *why*: why is the woman waving the flag and why is the liquid dissolving the salt? But in the former case I am looking for a reason *for* the woman to be waving the flag. In the latter case I am not looking for a reason *for* the liquid to be dissolving the salt.

This turns out to be a crucial distinction. In explaining why the woman is waving the flag I am providing a justification of the woman waving the flag.[1] I may say that she is waving the flag because there is an accident ahead. No such reason is sought or provided when trying to explain the liquid dissolving the salt. And it is the availability of this sort of explanation that seems to mark off actions from mere happenings. In this respect Anscombe was following in the footsteps of Aristotle. Aristotle argued that both natural phenomena and actions could be explained in terms of what they were *for*: "'Why is he going for a walk?' We say: 'To be healthy,' and having said that, we have assigned the cause" (*Physics*, II, 3, 194b33–35).

Explaining something in terms of what it is for is explaining it in terms of its end or "telos". So this sort of explanation is called *teleological* explanation. Teleological explanation is a species of explanation in terms of a reason. The man's going for a walk is for the sake of the preservation of his health, and this is also the reason *for* the man. Such a reason is called an *instrumental* reason. If you say what something is *for the sake of* you justify that thing.

It does not, however, follow that all reasons for action are instrumental. I might say that I gave back the money to someone because I promised I would. And if asked why I did what I promised to do I might say that it was because that is the right way to behave. Here I am not explaining what I do in terms of what it is for. Similarly if someone asks me why I just cheered I might say it was because England just scored a goal. This is not to explain my cheering as for the sake of anything, but it is to justify my behaviour.

Consider also cases of acting emotionally. Rosalind Hursthouse (1991) presents the vivid case of someone poking the eyes out of the photograph of her lover with a compass point. Why is she doing that? Because her lover has just betrayed her. This is real intentional action, but it would be psychologically untrue to describe it as done for the sake of something: for example, for the sake of making herself feel better. Perhaps it makes her feel a whole lot worse. She need not be doing it *in order to* express her emotional state but perhaps only *as* an expression of her emotional state. It looks as if

practical justifications may trade in other things than just instrumental reasons.

Hursthouse describes this as a case of "arational" action. She sees it as a counter-example to the general claim that all intentional actions are done for a reason. But it would be wrong to conclude from the fact that the eye-poking behaviour is not done for an instrumental reason that it is done for no reason at all, and that it is therefore arational: outside of rationality. There is a clear reason for the behaviour; namely, her lover has just betrayed her. So the action is not arational; it is just that it is not done to achieve any further goals.

That practical rationality can be other than simply instrumental is an important feature of Kant's approach. Kant argued that action was where reasons got involved in causality. He defined the will as "a kind of causality of living beings in so far as they are rational" (*Groundwork*, 97). And he thought that "pure" practical reason was non-instrumental rationality.

This pure practical reason was what constituted morality, according to Kant. And sensitivity to it manifested freedom. It was also precisely there that rationality constituted morality. So Kant identified acting freely with acting purely rationally, and also with acting morally. If you work out the way to behave without appealing to any goals that are themselves not rationally determined and bind your action to that way of behaving, you will be both free and morally virtuous. It is certainly an attractive vision if you can believe in it. In this chapter I shall look in more detail at the nature of practical rationality and its relationship with action, although I shall get nowhere near assessing Kant's ambitious programme of grounding morality in the idea of practical rationality.

Functions outside of agency

As I mentioned, Aristotle claimed that both actions and natural phenomena, such as human beings' having teeth, for example, are explained teleologically. This raises a challenge for Anscombe's rationalistic approach. It seems that not only intentional actions but also these other natural phenomena give application to her sense of the question "Why?". We explain human beings' having teeth by *justifying* human beings' having teeth: they are for the sake of eating.

Yet, of course, human beings' having teeth is not an intentional action.

The same goes for anything with a natural function. Why does the sunflower turn to face the rising sun? The answer (I suppose, although I wait to be corrected) is that the seeds warm up faster, and this aids ripening. This is a justification of the sunflower's behaviour. The function of the behaviour is to enable the seeds to ripen most effectively. But the behaviour is not an intentional action.

The same goes for artificial functions. Why is there a belt linking the motor with the alternator in a car's engine? The answer is that this way some of the energy generated in the motor from the fuel combustion can be transferred into electrical energy in the battery. This is a justification. It answers the "Why?" question in the same sort of way as explanations of intentional action answer the "Why?" question. But there being a belt linking the motor with the alternator is not an intentional action. So Anscombe's criterion for intentional action does not seem to work.

The inward-looking approach to agency has a response to examples like these. According to the inward-looking approach, what characterizes intentional action is the presence of some appropriate mental state. Since, evolution, sunflowers and automated automobile production lines have no mental states, they have no agency and are not acting intentionally. The challenge is for the *outward-looking* approach to see if it can explain why such things should not be characterized as involving agency and intentional action.

I think there is a reasonable way to meet this challenge, although it requires some fine distinctions. It is to deny that in the cases of functions outside of agency, one thing (the thing with the function) may be explained in terms of what that *very* thing is for the sake of. It is too loose to say that a particular specimen of a sunflower turns towards the rising sun because that piece of behaviour will enable its seeds to ripen most effectively. A specimen of a sunflower turns towards the rising sun because it has a phototropic mechanism of a certain sort. If doing something else turned out to be the way to enable its seeds to ripen most effectively, the particular sunflower would *not* adapt to that, but would still turn towards the rising sun due to this mechanism. So the justification of that specific bit of behaviour of the sunflower specimen does not explain why that specific bit of behaviour occurs. Could we perhaps still say that it has

the phototropic mechanism because having such a mechanism enables the seeds to ripen most effectively? But again, that particular sunflower does not have such a mechanism because *its* having such a mechanism has that result. It has that mechanism because of the genes it has along with various developmental conditions.

If you ask why a particular specimen has the genes it has, the explanation will be in terms of a series of mutations and reproductions in its family history. Part of that explanation will be that this particular sunflower has the genes because its parents did and they survived to the point of reproduction. And part of the explanation of their survival may well be that their having a phototropic mechanism enabled their seeds to ripen fastest. But this is to explain why one sunflower has a phototropic mechanism in terms of what its *ancestors* having a phototropic mechanism was for the sake of. This is not to explain one thing in terms of what *it itself* is for the sake of.

Consider an analogy. Suppose there is a cave with only one very small entrance hole at the top. And suppose that on the floor of the cave are some pebbles, none of which are bigger than that hole. Take one pebble and ask why it is so small. The answer is not going to have anything to do with the hole in the roof. The answer is not that it is that small because only pebbles that small will get through the hole in the roof. That pebble would be that size whatever the details of the cave. The correct answer will refer to the process of erosion that has made that pebble that size. But if we ask why the pebbles on the floor are all so small there is an ambiguity. We might be asking for each pebble why it is so small: why this one is so small; why that one is so small; and so on. Alternatively, and more plausibly, we might be asking why it is the case that the pebbles that are on the floor are all so small; why there is a prevalence of small pebbles on the floor. And this time we can appeal to the size of the hole in the roof. The reason the pebbles are all so small is that only small pebbles fit through the hole in the roof.[2]

In evolutionary explanations, then, you do not explain some feature *F* in terms of what *F* is for the sake of. You may explain the prevalence of *F* in a *population* in terms of what *F* is for the sake of in an *individual*. Or you may explain the presence of *F* in some individual in terms of what the presence of *F* in earlier generations was for the sake of. In neither type of explanation are you explaining something in terms of what it is for the sake of.

However in the case of explaining action, you are explaining something in terms of what it is for the sake of. For example, you explain someone waving in terms of what that very waving is for the sake of. So Anscombe's approach to agency is not undermined by these examples of apparently teleological explanation outside of agency. Although justifications are provided in these explanations, the explanations are structurally different from explanations of action. This difference can be accounted for without mentioning the lack of internal mental states.

Is all intentional action done for a reason?

Anscombe's characterization of action that I began this chapter with does not in fact require that all action is for a reason. She is very clear that when someone acts it is appropriate to ask them for a reason, but that *there may be none*. This is by contrast with those things where it would not even be appropriate to ask for a reason. For example, if someone asks you why you just squashed that invisibly small bacterium under your thumb as you picked up a pen, it would not be appropriate to say "For no reason". It would be more appropriate to say instead that the question does not apply. Whereas if you idly but deliberately squashed an ant, there might be no reason, but the question "Why?" still has application.

> Now of course a possible answer to the question "Why?" is one like "I just thought I would" or "It was an impulse" or "For no particular reason" or "It was an idle action – I was just doodling." I do not call an answer of this sort a rejection of the question. The question is not refused application because the answer to it says that there is *no* reason, any more than the question how much money I have in my pocket is refused application by the answer "None". (Anscombe 1957: 25)

You might think that even these idle actions are done for a reason. Perhaps the reason is that I felt like doing it or it appealed to me in some way or just to see what it would be like. But it may be quite artificial to suppose that such a reason is in place. For example, perhaps I did not really feel like squashing that ant; I just did it without thinking, even though I was disgusted at myself for doing so and

did not enjoy doing it at all. Of course, there must be some sense in which I must have wanted to do it, or else I would not have done it. But to say that I wanted to do it in that sense is to say no more than that I was motivated to do it. And this does not provide a *justifying* reason. Why should the fact that I was motivated to squash an ant make that the thing to do?

In this case my top-level goal is simply to squash an ant; there is no higher characterization of my behaviour available that might justify it. If you describe an action in terms of its top-level reason, then there will be no further reason. But Anscombe's point is that you can still *ask* for a further reason, even when there isn't one. Intentional actions, which are not done for any further reason, are still subject to justification (as well as criticism). And this distinguishes them from bits of activity in the world that are not intentional actions.

At this stage I should flag up something that I shall not consider properly until Chapter 5. When I am talking about an action being *subject* to justification I am not just talking about some *possible* justification; I am talking about the justification that *applies* to that action. This is the justification that the action has a place in and that the agent is committed to in acting this way. Eventually I shall argue that this requires the agent to be *causally sensitive* to this justification. But for the time being I shall try to remain neutral as to whether the idea of being subject to justification is a causal idea, partly because Anscombe and many other like-minded philosophers of that period thought that it was not.

What is a system of justification?

It is clear from the discussion so far that if it is right to characterize intentional action as subject to justification, the notion of justification in play here had better be very flexible. To put it rather strangely, the sort of justification that intentional action is subject to may itself be quite unjustified. You may have reasons for action that are bad reasons. Such reasons can still justify an action, even though the action is not in some absolute sense justified. A bad reason justifies an action according to a system of justification that is itself a bad (or unjustified) system of justification. This needs to be explained.

Let me start by considering theoretical justification and theoretical reasons: justification and reasons for *belief*. Suppose that someone claims that their lover is fickle because their star sign is Aquarius. The reason for saying their lover is fickle is that their star sign is Aquarius. That their lover's star sign is Aquarius justifies their belief that they are fickle. This is using a particular astrological system of justification. It is a bad system of justification. So in some absolute sense their belief is not justified. But in a relative sense it is justified; it is justified by the astrological system. In the same way one might concoct a religious justification for claiming that homosexuality was immoral. That particular religious belief system provides a reason for believing that homosexuality is immoral: a bad reason provided by a bad system of justification.

Scientific induction is another system of justification, one that philosophers have found hard to justify although bound to accept in some form. The fact that the sun has risen every morning up until now may be the reason for my believing that it will rise tomorrow morning. My belief is justified by induction; but whether it is absolutely justified depends on whether induction itself is a good scheme of justification.

A system of theoretical justification is a way of deriving conclusions or beliefs. The inputs into such a way of deriving beliefs are reasons for those beliefs according to that system. I want to say that there might be many such systems, astrological, religious, scientific and so on. But this may be denied. An alternative view is that there is only one system for deriving beliefs: deductive logic.

According to this alternative view, what I have been taking to be an astrological system of justification is really deductive logic with a set of assumptions: for example, that anyone whose star sign is Aquarius is fickle. To the extent that these assumptions are false, astrology fails to justify our beliefs after all. Someone's belief that their lover is fickle is not justified by the fact that their lover's star sign is Aquarius along with other facts since it is impossible to deduce this conclusion from such facts.

If the only system of theoretical justification were deductive logic then the idea of a bad justification or a bad reason would make no sense. Either a proposition is logically deducible from other facts – and therefore justified by those facts – or it is not. There would be no scope for some belief to be justified by a bad system of justification.

There are reasons, however, for questioning this idea that the only system of theoretical justification is deductive logic. For one thing, there is no single deductive logic. There are classical logic and intuitionistic logic (as well as many less promising alternative logics), and they lead to quite different conclusions. For example, in intuitionistic logic one cannot conclude of an arbitrary proposition, p, that either it is true or its negation is true, whereas this result can be derived in classical logic.

For another it may not always be possible to make explicit the assumptions that a system of justification appears to presume, and yet still be possible to employ such a system. A scientist can apply scientific method without committing themselves to a particular set of assumptions from which they are deducing their conclusions. The ability to make scientific inferences does not seem to depend on the ability to grasp the system of assumptions that would need to be made in order to think of scientific method as a case of deductive logic.

One final consideration in favour of the idea of systems of justification other than deductive logic is the possibility of deriving justified beliefs not by inference from other beliefs but by some direct engagement with the world. For example, I may form the justified belief that there is a cup on the table in front of me because there is a cup on the table right in front of my eyes.

If we assume that my belief is only justified by a system of deductive logic from other beliefs, then we have only two unpalatable alternatives available. Either my belief is not justified at all, which is scepticism, or my belief is logically deducible from some belief about how things *appear* to me. In this latter alternative, the fact that there is a cup in front of me must be logically derivable from facts about appearance; this is idealism.

But if we assume instead that logical deduction is not the only system of justification, we may posit a visual system of justification according to which the belief that there is an object of a certain sort in front of one can be derived when an object of that sort really is in front of one's eyes (and some other conditions are satisfied). It is a system of justification, albeit one that only a sighted person can employ.

When we move from theoretical justification to practical justification the case for allowing various different systems of justification

is even stronger. Think of a system of practical justification as a way of deriving recommendations for action. Prudential self-interest might be one such system. An ethical system might be another. And, as with systems of theoretical justification, there might be systems of practical justification that are themselves bad or unjustified.

For example, a football hooligan employs some system of deriving recommendations for action that we would not think of as providing *absolute* justifications. Still, the fact that some innocent bystander was waving a Chelsea scarf may count as a reason for attacking that bystander, according to the hooligan's system of justification. While we resist saying that they were justified in attacking the Chelsea supporter, since this implies an absolute justification that is clearly lacking, we might accept that there is a way (a bad way) of justifying that behaviour.

As we shall see in Chapter 3, David Hume thought that practical justification must use either deductive or inductive logic, so he was very sceptical about the scope of practical justification. But the football hooligan does not apply deductive logic to a set of laws of the form: in such and such a situation do such and such. They learn a way to behave. And it does not seem to be helpful or even always possible to reduce this way of behaving to the application of deductive logic to certain assumptions.

One approach to ethics, know as moral particularism, claims that ethical systems of justification cannot be reduced to a system of explicit rules of behaviour.[3] The infinite particularity of every concrete situation defeats any attempt to codify a way of behaving. And the way to learn a way of behaving is not to learn a system of rules but to acquire a moral sensibility that gives one sensitivity to moral reasons.

It appears to be a mistake to restrict practical justification to deductive logic. However, analytic philosophers are often pretty distrustful of this talk of *systems* of justification, since such talk has often been used by postmodernists to motivate a kind of knee-jerk relativism about everything. Postmodernists assume that any justification works with some system of justification. They might call this a language game (borrowing the term quite illegitimately from Wittgenstein) or a narrative (Lyotard).[4] And within each system, game or narrative, certain things should be said and believed; but these things will vary from system to system. According to postmodernism, there is no "grand narrative" or God's-eye perspective

from which to challenge the results of any system; there is nothing objectively wrong with astrology, it is just that I choose not to practise it; the democratic thing to do is to play around with lots of different systems, not allowing oneself to settle too long lest it gives one a false sense of authority for that game over the others.

This sort of relativism, however, does not follow from the initial assumption that justifications employ systems of justification. For this assumption is compatible with the realist idea that when different systems of justification conflict one or both must be rejected. The drive for ever more inclusive and coherent systems of justification will lead to some systems of justification being preferred to others. Even if there is no super-system of justification, we still have the resources to reject astrology or football hooliganism as bad systems of justification. So there is really no need to resist the natural idea of recommendations for action being justified by particular systems of justification.

The structure of practical justification

The real issue is how should such a justificatory system be taken to work. What is the logic underlying practical justification? Or, assuming that there might be many different sorts of justificatory systems for action, what do their logics have in common?

One thing that seems to be necessary to any way of making recommendations for action is that it includes some element of teleological or means–ends logic. This does not mean that every practical reason is an instrumental reason. There may be room in a system of practical justification for both instrumental and non-instrumental reasons. What it means is that, since not all goals can just be achieved directly, ways of achieving them must be worked out. Some inferential rule such as the following one must be part of the system:

> If X is to be achieved and Y is part of the best way to achieve X, then Y is to be achieved.

For example, if you are to spend a happy day with your children and the best way to achieve this goal is to go to the park, then going to the park is the thing to do.

It is often claimed that the rule of inference for teleological justi-fication should be less demanding than this. There may be many ways to have a happy day with one's children, none particularly better than another. But you are still justified in going to the park, since that is a *satisfactory* way of achieving the goal even if it is not the *best*. If your goal is to pick a can of beans from a shelf you are justified in picking the third one from the left, even though there is nothing to recommend doing that rather than picking the fourth one from the left. Given this it is sometimes claimed that the rule should be something more like this:

> If X is to be achieved and Y is part of a satisfactory way to achieve X, then Y is to be achieved.

This kind of rule was described by Anthony Kenny (1966) as defin-ing the logic of *satisfactoriness*. What makes this interesting is that different incompatible courses of action can be recommended by the same system of justification. You should pick the third can from the left since it is a satisfactory way to achieve the goal of getting a can of beans, and by the same token you should pick the fourth can from the left. But at the same time you should only pick one can.

This might make it look as if the logic of satisfactoriness is incon-sistent. But with a bit of care it can be made to work. In standard logical systems if we are entitled to infer A and we are entitled to infer B, then we are entitled to infer [A and B]. But in this system we should not allow the inference from "pick the third can from the left" and "pick the fourth can from the left" to the conclusion "pick the third can from the left and pick the fourth can from the left". Both recommendations are individually justified. But their conjunction is not. Similarly, in standard deductive logic we are not entitled to infer A from [A or B]. But in the logic of satisfactoriness we are. If we can recommend either picking this can or picking that can, we can derive the recommendation to pick this can; and we can derive the recom-mendation to pick that can. What we cannot derive is the recommen-dation to pick both cans.

It is certainly a fascinating idea that the logic of practical justifi-cation should have these odd features. But this is not the only way to deal with cases like the indistinguishable cans of beans. Another approach would be to say that although picking *a* can of beans is

justified, picking that particular can of beans is not justified. You have no reason for picking that particular can of beans, although you do have a reason to pick a can of beans. You could make it justified arbitrarily by making it a top-level goal. This is what you do when you say to yourself "That's the one to go for". But once that is the case, then picking any other can is no longer justified.

A system of justifying actions may include arbitrary top-level goals. Another system would work with different top-level goals. It may also include ways of changing top-level goals in the light of circumstances. If one goal is not achievable, or only achievable at a cost, then it may make more sense to change the goal than to grind on with means–ends recommendations. So it may be the case both that a system of justification recommends achieving some top-level goal and that it recommends changing itself in the light of the inappropriateness or unattainability of this goal, so that it no longer recommends achieving that goal. A system of justification is itself subject to further justification. This means that it has to be regarded as a dynamic evolving thing, just as Hegel took it to be.[5]

A system of practical justification is a way of making recommendations for action. It says how one should behave. There will be as many such systems as there are ways to behave: indefinitely many. And they will encompass different ethical perspectives and different practical perspectives. There is one way to infer behavioural recommendations for the football hooligan and another for the train spotter. Some of these ways may be unstable since, once examined properly, they would no doubt need to evolve in the light of conflicts and inconsistencies.

Is all intentional action subject to justification?

It should be clear by now that the rationalistic approach to agency does not require people to be super-rational agents: always acting in a logical and justified way. Of course people are not like this; they are emotional rather than logical and they do not always act in an absolutely justified way. A human creature who is not fully rational is no less an agent, and no less a person.

The Aristotelian–Kantian approach is often accused of being rationalistic or essentialist, of failing to recognize the plurality of possibilities in being a human being. It is also often accused of being

chauvinistic: of identifying human nature with a logical masculine ideal and denying the feminine emotional side of people as an aspect of agency at all. In the process it is argued that this approach is really designed to deny women proper status as human agents.

This is all just loose thinking, however. There is nothing in the idea of acting for a reason or acting in a way that can be justified that is incompatible with acting emotionally. It is absurd to think of justification as requiring a bloodless calculating logicality. And to make this a feminist issue is very dangerous, since this would mean appealing to one of the nastiest sexist stereotypes: that of women being illogical, irrational, emotional and instinctive, with men being goal-directed, intelligent and reasonable.

To avoid all this we just need to make sure that the idea of an action being subject to justification is an inclusive enough idea: that it includes emotional and intuitive behaviour as well as goal-directed behaviour. Indeed, it had better include immoral and completely psychotic behaviour too, since these are all possible aspects of human agency. Certainly it does not require that the agent engage in a conscious process of reasoning or deliberation.

Consider the abusive behaviour of someone suffering from some kind of psychotic condition. I used to walk past a man every day who would shout and swear at everyone he saw. This behaviour was clearly intentional behaviour, and in some way was also subject to justification. I would sometimes ask him why he was shouting at me, and if I gave him a cigarette and he was in a good mood he would reply, "You were looking at me in a funny way" or, perhaps, "You were avoiding looking at me." These are not good justifications, but they do provide some kind of justificatory framework for the action. According to these systems of justification, shouting at the stranger is recommended as the thing to do. So the behaviour is justified by a certain system of justification, even though that system is itself unjustified and wrong.

But the psychotic agent may not have such a justification available to them; and indeed in this particular case I did not believe the answers were genuine. The man may not know why he is shouting. In such a case there may be a way of justifying the behaviour that the psychotic person cannot themselves recognize. A psychoanalyst observing the scene might observe that the person shouted at the stranger in order to frighten them and by so doing make themselves feel less defeated

by their own anxiety and fear. However this sort of psychological rationalization does not really present the agent's reasons for acting. It seems irrelevant to the question of whether the behaviour is intentional and expresses genuine agency whether or not there is a good psychoanalytic explanation available.

Perhaps the best we can do is to say that that person is quite mad and just shouts at people for no reason. But this does not mean that the behaviour is not subject to justification. The shouting behaviour was often quite well worked out and adaptive to the circumstances. For example, he did not shout when he thought he might get a cigarette by asking someone instead of shouting at them or when he thought he might get into really serious trouble by shouting. And when he did shout there was a fair amount of positioning and timing required to get it right.

Compulsive eating is another familiar case of this sort of thing, as are various addictive compulsions. Here the agent is clearly acting intentionally and the behaviour is subject to justification. The agent has to go out and buy the food or the cigarettes or the crack cocaine, and if for some reason they cannot acquire them they will have to adapt their behaviour. Their way of behaving – and the system of justification that their behaviour has a place in – is relatively inflexible with respect to this top-level goal. Even when this goal should be eliminated in favour of some better goal, it will often still determine how the agent behaves. The way of thinking that justifies the agent's behaviour may not work perfectly as a rational system, but it is still the case that the agent's behaviour is justified within such a system.

Such highly compulsive behaviour seems to be the result of an *idée fixe* that the shouting man or addict or compulsive eater cannot or does not want to rid themselves of. But it is intentional and it is sensitive to reasons: reasons that fit into a system of justification that embeds the absurd or undesirable *idée fixe*. The case of Tourette's syndrome is quite different. Here there is almost no sensitivity at all to reasons. There may be a bizarre logic to the choice of verbal or bodily tics, but it is not a logic that connects with the way the Tourette's sufferer lives their life; it is not *their* logic.

Sub-intentional action

Even if all intentional action is somehow subject to justification, it might be argued that not every expression of real agency is an intentional action. Brian O'Shaughnessy talks about the moving about of one's tongue in one's mouth. Apparently this is going on all the time without one's being aware of it. One's tongue is probing around in one's mouth seeking out bits of food left hanging around there. You usually only realize your tongue is doing this when it keeps coming up against a new filling or a newly chipped tooth and cannot leave it alone.

According to O'Shaughnessy, when I become aware of my tongue, "I become aware, not merely of *a movement* of my tongue, but of a movement that *I have executed*. But more, I become aware of *an activity of moving* that is being performed by me" (1980: 60). So he is arguing that the tongue is not merely moving; it is *being moved* by me. My agency is fully involved. Yet, according to O'Shaughnessy, "the faculty of reason is completely by-passed" (*ibid.*: 61).

We can apply Anscombe's test to this case, and ask, "Why did you move your tongue that way?" The proper answer I think is not "For no reason". It is not like idly doodling. The proper answer is to reject the question as inappropriate; the question "Why?" in that sense has no application here. So, presumably Anscombe would agree with O'Shaughnessy to the extent of denying that such action counts as intentional action in her sense. Where O'Shaughnessy departs from Anscombe's rationalistic view is in his assertion that such action is still an expression of agency.

Thus O'Shaughnessy argues against identifying agency with anything involving reasons. He has an uncompromisingly inward-looking approach to agency, regarding the existence and activity of the faculty of the will to be what marks out true expressions of agency. The will is engaged when the tongue moves, since, according to O'Shaughnessy, the tongue's moving about is a type of "striving".

Now the unconscious movements of the tongue certainly have a wonderful complexity to them. If you watched a video of your own tongue from a hidden camera on the inside of your cheek you would see something that was behaving as though it had a life of its own. It would look like a simple animal poking around exploring its limited environment, in some ways like the snail I mentioned in Chapter 1. But it does not follow that these movements express your agency.

Like breathing and blinking, moving your tongue is something that you can bring under your control and make part of your agency for limited periods of time. And you can also, although with some difficulty, become aware of your breathing, blinking or tongue moving without bringing it under control. It is then really on the edge of being an intentional action, and on the edge of being a real expression of agency. But it does not follow from this or from the vagueness of the distinction between cases that are and cases that are not intentional actions, that the movement of the tongue is unequivocally a different sort of expression of agency: a sub-intentional action. Indeed normally it does not seem to have anything to do with agency.

Conclusion

In this chapter I have introduced a rationalistic approach to agency. The idea is that what characterizes intentional action is that it is subject to justification. Even if there are no reasons for an intentional action, it is the *sort of thing* for which it is appropriate to ask for a reason. I have suggested that this rationalistic approach to agency does not impose too heavy a burden on us as agents. It is possible to behave in a way that is rationally justified even if that behaviour is at the same time quite irrational or mistaken. Rational justification should not be equated with logical deduction, and a system of rational justification need not be thought of as being fixed and perfect.

3 Reasons and passions

States of mind as reasons for action

In chapter 1 I distinguished two very broad approaches to the philosophy of action: the inward-looking approach and the outward-looking approach. According to the inward-looking approach we should look for the essence of agency in certain characteristic mental states, events or acts that accompany or cause physical behaviour. According to the outward-looking approach, we should look for the essence of agency in the acting agent's relationship with their environment: the adaptability of what they do to what they *should* do given the way the world is.

The idea, introduced in Chapter 2, that intentional action is essentially subject to justification is a way of putting some content into this second, outward-looking, approach. But this depends on justification *itself* being an outward thing not an inward thing. I have implicitly been assuming that it is: that behaviour is justified in virtue of its relationship with how the world is rather than being justified in virtue of its relationship with the agent's own mental states. So, in doing what you should do you are responding to the requirements of your environment rather than the requirements of your own psychology (although *how* you respond to the requirements of your environment is related to your psychology).

This assumption, however, can be questioned. The very opposite is simply taken for granted by many philosophers working on the nature of rationality and justification. They say that what you should do rationally – what you are justified in doing – is determined by what you believe and by what you want; and your beliefs and desires

are metal states. If you do not *want* to support the English football team you have no reason to cheer when they score a goal. And even if you do want to support them you have no reason to cheer if you do not *believe* that they have scored a goal, whether or not they have.

There are two ways of spelling out the idea that an agent's reasons for action are determined by their states of mind: beliefs, desires and so on. The simplest way is to say that reasons for action must themselves *be* beliefs and desires. The subtler way is to say that reasons for action may be external environmental considerations, but that what makes them reasons for the agent is the agent's set of beliefs and desires. I shall examine these two in turn.

The belief–desire model of practical justification

The first is often described as the Humean model of practical justification, although I defy anyone to find it stated explicitly by Hume. It is better described as the belief–desire model of practical justification. In his article "Actions, Reasons and Causes" (1980: essay 1) Davidson presented the idea in the following way, although it may be unfair to attribute the belief–desire model to him as he did not take reasons to be *justifying* reasons in the sense outlined in Chapter 2:

> Whenever someone does something for a reason, therefore, he can be characterized as (a) having some sort of pro attitude towards actions of a certain kind, and (b) believing (or knowing, perceiving, noticing, remembering) that his action is of that kind. (*Ibid.*: 3–4)

So whenever you do something, part of your reason for doing it must be that you want to achieve some result and another part of your reason is that you believe that doing this achieves that result.

For example, I might pick up a pen for no apparent reason. But, according to Davidson, my reason for doing what I do is at the very least that I want to pick up the pen or feel like picking it up or am in some way positive towards doing that. And part of my reason must also be that I believe that doing *this* (where the word "this" points to the action) is picking up the pen. So in answer to the question "Why are you doing that?" I may say that my reason is that I believe that that is an action of picking up a pen and I want to pick up a pen. Or I might

pick up a pen with a further end in sight; perhaps I pick up the pen with a view to signing my name. Then my reason for picking up the pen is a complex of different psychological states that work together. One part of the reason is that I want to sign my name, and another is that I believe that picking up the pen is what I need to do in order to achieve my desire to sign my name. Another part of my reason, as before, is that I believe that *this* is an action of picking up a pen.

It may be even more complicated than that. Perhaps we have to include as part of my reason my belief that picking up the pen does not interfere with other things I want to achieve. Perhaps we have to include my desire to do whatever I need to do in order to achieve my first-order desires. But however complicated we make the model of belief–desire practical justification, the key presumption is that every reason must include some desire as well as some belief.

It is important to realize that this model of practical justification does not assume that all justified action must be instrumental and that the only justification is means–ends justification. The example of picking up a pen because I want to sign my name is obviously an example of an instrumental action. But when I pick up the pen just because I feel like it, there is still a belief and desire that can figure as reasons for doing what I do: the desire to pick up the pen and the belief that that is what I am doing.

When an England football supporter cheers when England scores a goal they are not cheering in order to achieve some further end, although in some cases they might be. But they must both want to cheer an England goal and believe that that is what they are doing. So in a fairly minimal way a belief–desire model of practical justification applies to non-instrumental as well as to instrumental action.

The first thing to do is to clarify the use of the words "belief" and "desire" in this model. There is a possible ambiguity in saying that someone's beliefs justify how they behave. We might mean that it is their being in a certain state of mind – that of believing something – that justifies what they do. Or we might mean that it is *what* they believe – that is, the *content* of their state of mind – that justifies what they do.

For example, in the first sense, I might infer from your belief that the CIA is spying on you through your television that you are paranoid and should seek treatment. In this sense I am deriving a recommendation for your behaviour from the *fact that* you are in such a

state of belief. In the second sense, I might infer from your belief that the CIA is spying on you through your television that you should lodge a complaint, get a new television or leave the country under an assumed name. In this sense I am deriving a recommendation for your behaviour from what you believe, not from the fact that you are in such a state of belief.

In the second sense of belief the belief–desire model of practical justification would not be such an inward-looking model after all. Recommendations for action would not be made on the basis of what mental state of belief the agent is in, but on the basis of the external considerations that the agent believes to hold. It may still be the case that these external considerations only count as reasons for the agent in virtue of the agent's mental state; this is something I shall consider later in the chapter. But on this interpretation of the belief–desire model, we would not have to think of a rational agent as responding rationally to their own psychology as opposed to responding rationally to the way the world is.

It is the first sense of belief that makes the belief–desire model of practical justification an inward-looking affair. The basic rule implicit in any system of practical justification would be something like: *do whatever you believe achieves what you most want to achieve.* And it is this interpretation of the belief–desire model that I want to consider and challenge in this section.

The word "desire" (or the word "want") is also used in a very particular – indeed peculiar – way in this model. If you want to step aside in order to avoid walking into a tree you are described as having a *desire* to step aside. This is not supposed to capture any powerful emotional content in your state of mind. On the contrary, desires are supposed to be what you have whenever you are motivated to do anything. The thing that you have the strongest desire for – that you most want to achieve – is not the thing that you have the most powerful feelings about.

If you were following an ascetic or self-denying way of life, it might be rational for you to deny yourself the things you had the most powerful feelings about. If wanting something most were the same as having the most powerful feelings about it, then, as an ascetic, your wanting most to eat a bun would be your reason for *not* eating the bun. Here you would be going directly against the rule to do whatever you believe achieves what you most want to achieve.

Yet your behaviour would still be justified. So you did not really want most to eat the bun, or else you would have eaten it. Your desire not to eat the bun was stronger than your desire *to* eat the bun even though your desire *to* eat the bun had more emotional vivacity. According to this way of understanding things, it follows logically that you will do whatever you believe achieves what you most want to achieve, other things being equal.

Given this, it is not a recommendation of practical justification that you *should* do whatever you believe achieves what you most want to achieve; it is rather an unpacking of the concept of wanting that other things being equal you *will* do whatever you believe will achieve what you most want to achieve. It does not follow from your most wanting not to eat a bun that you *should* not eat a bun; it follows that you *will* not eat a bun. (If you could not stop yourself and ate the bun anyway, you must have wanted to eat the bun more.)

If the maxim "Do what you most want to do" just describes what you will do in virtue of wanting to do it, then it is not a maxim of practical justification. In the sense in which it might really be a maxim of practical justification and there is a genuine choice as to whether or not to do what you want, then this maxim is not a *universal* maxim of practical justification. Choosing not to do what you want in this sense is intelligible and might even be justified.

It seems that neither way of understanding the notion of wanting enables the maxim "Do whatever you believe will achieve what you most want to achieve" to provide a fundamental rule of practical justification. I think the same goes for the role of beliefs in that maxim. Suppose an exam invigilator wants to stop the exam after exactly three hours, but after two hours forms the belief that three hours have elapsed and stops the exam. Was she justified in doing that by the fact that she *believed* that three hours had elapsed?

Consider two possible rules for exam invigilators:

- Rule 1: Stop the exam after and only after you believe that three hours have elapsed.
- Rule 2: Stop the exam after and only after three hours have elapsed.

Which of these rules justifies and governs her behaviour as an exam invigilator? If it is Rule 1, then she has made no mistake in stopping the exam after two hours. She has done exactly what she is supposed

to do. She has made a mistake in what she believes, but this is not a mistake of conduct. It is bad *action* one should apologize for, not bad *belief*. So she would have no need to apologize for her behaviour.

It is clearly Rule 2 that determines right and wrong behaviour for an exam invigilator. She has behaved wrongly, not just believed wrongly when she stops the exam after two hours. And, since Rule 1 has not been violated, it must be Rule 2 that she has violated, and should have followed. Rule 2 does not mention beliefs but only external circumstances.

Someone might try to say that both rules apply to the exam invigilator. But I think that would be a hard position to sustain. For it would then follow that in the case where she got it right and truly believed that three hours had elapsed, she would have *two* reasons for action. She would be doubly justified in stopping the exam; she was justified by the fact that three hours had elapsed and she was also justified by the fact that she believed that three hours had elapsed. But this is absurd.

Jonathan Dancy (2000: 124) argues for the same conclusion in the following way. There are cases when the reason for acting in a certain way is that you believe something. But these cases are so obviously strange that we can see in the normal cases that the fact that you have some belief is not a reason for acting. His example is a walker contemplating whether or not to climb up a cliff. The walker knows himself well enough to know that if he *believes* it is dangerous he will panic and probably trip and fall.

Now, whether for good reason or for bad reason, the walker does form the belief that the cliff is crumbly and as a result dangerous. Here the very fact that he has this belief is a good reason not to climb the cliff. Whether or not the cliff actually is crumbly and whether or not his belief is completely irrational he should not climb the cliff, since, having the belief that it is crumbly, he is likely to trip and fall.

He is in a different position from the confident but safe walker who will avoid dangerous situations but is not more likely to fall just because he believes he is in a dangerous situation. Indeed this walker may respond to believing that the cliff is crumbly by taking more care. So that he believes the cliff is crumbly actually makes it safer for him to climb the cliff than if he did not believe it was crumbly (assuming in both cases that the cliff actually is crumbly). For the confident walker the *fact* that the cliff is crumbly is the reason not

to climb it; that he *believes* it is crumbly does not give him an extra reason, as it does for the nervous walker.

Normally we are in the position of the confident walker. We are not looking to our own psychological states to work out what to do. We look outwards to the way the world is around us, and find our reasons for action there. Inward-looking reasons are special cases. Sometimes you need to consult your own psychological state in order to work out what you should do. But in the vast majority of actions you need to look outwards to work out what you should do. The exam invigilator should consult the clock, not her state of mind.

The difference between a reason for acting and a reason why you act

However compelling this argument is, there is still the awkward fact that even in the standard outward-looking cases we do say that the reason we act is that we have a certain belief. For example, if the invigilator did stop the exam after two hours, she might well claim that the reason she did so was that she believed that three hours had elapsed.

I think if we are careful we can use ordinary language to mark an important distinction. The invigilator will not say that the reason *for* her stopping the exam was that she believed that three hours had elapsed. That was not a reason for stopping the exam after two hours. Saying that the reason *why* she stopped the exam after two hours was that she believed three hours had elapsed is saying something different. There seems to be a subtle difference between something being a reason *for* acting in a certain way or *to* act in a certain way on the one hand, and something being a reason *why* you act in a certain way on the other hand.

Suppose a vandal smashes up a telephone box. It is not the case that a reason *for* smashing up the telephone box is that he is a vandal. Or at any rate, this would only be the case if the vandal were strangely self-conscious: "Look, your honour, I'm a vandal; I have to fulfil my nature and smash up telephone boxes. My reason for doing it is that I am a vandal." For the less self-conscious vandal the fact that he is a vandal is not part of the justification of what he does. But even for the less self-conscious vandal it is the case that one reason *why* he smashed up the telephone box is that he is a vandal.

A reason *why* he acted need not be part of a justification, whereas a reason *for* his acting must be.

When you ask the supporter of the England football team why they just cheered after an England goal, they might say one of the following two things: "I cheered because England just scored a goal" or "I cheered because I am an England supporter". But these should be taken to be quite different ways to answer the question. Their reason *for* cheering was that England just scored a goal. But although one reason *why* they cheered is that they are an England supporter, this is not a reason *for* cheering (alas). This is because they are not subject to a system of justification that says if you are an England supporter and England have just scored a goal you should cheer, but if you are not an England supporter you should not cheer. The system of justification that an England supporter's behaviour is subject to makes no such conditional recommendations. Their rule is just to cheer when England score.

Saying that you are an England supporter is to say something about the system of justification into which the reasons *for* your behaviour fit. Being an England supporter means that the fact that England just scored is a reason for you to cheer. Being a vandal means that the fact that smashing a telephone box is very annoying is a reason for you to smash the telephone box.

It is important to reiterate that the notion of justification in use here is a relativistic one. The central notion is that of being justified *in a particular system of justification*. This allows us to say that there is a reason for the vandal to smash up telephone boxes, even though, using an absolute conception of justification, we would want to say that there is no reason for him to do so. His behaviour is justified by a *bad* system of justification.

In the same way, if the invigilator says that she believed three hours had elapsed, she is saying something about the system of justification that does (or would) provide reasons for her behaviour. It is a system of justification that works on the assumption that three hours have elapsed, and so it too is a bad system of justification. Her believing that three hours have elapsed means that her behaviour is subject to such a system of justification; and this means that the fact that it is supposed to be a three-hour exam is a reason *for* her to stop the exam. Her false belief that three hours have elapsed is not a reason *for* her to do anything, but is a reason *why* she stops the exam.

This brings us back to the subtler way of understanding the idea that an agent's reasons for action are determined by their beliefs and desires. Even if the agent's reasons for acting are not themselves usually beliefs and desires, it may be that an agent has the reasons for acting as they do in virtue of having the beliefs and desires they do. That an agent has the beliefs and desires they do is a fact about the system of justification that applies to them. This is what I consider in the rest of this chapter.

Internal and external reasons

We have seen that the invigilator's stopping the three-hour exam after two hours may be justified by a system of justification that works on the false assumption that three hours have elapsed. But it is also true that she had reason *not* to stop the exam after two hours. The *fact* that only two hours had elapsed was a reason for her not to stop the exam. When we say that she made a *mistake* stopping the exam so soon, we are saying that she failed to do what she should have done according to that justification.

This is a more straightforward system of justification, one that does not work on any false assumptions but makes its recommendations on the basis of the facts. The careless invigilator's behaviour is not properly sensitive to this system of justification, but it *should* be. And when she acts properly her behaviour is sensitive to it. So we can say that the fact that only two hours have elapsed is a reason for her not to stop the exam, *whatever* her beliefs on the matter might be.

It is true both that she had reason for stopping the exam and that she had reason for not stopping the exam; both are justified. This is possible because there are two different systems of justification that apply to her behaviour – one that works on a false assumption about how much time has elapsed and one that is sensitive to how much time has actually elapsed. The latter justification applies independently of what she believes.

This point appears to threaten even the subtler way of understanding the belief–desire model of practical justification mentioned earlier. According to this subtle version of the belief–desire model, we only have the reasons for acting that we do in virtue of having the beliefs and desires that we do have. Not only is the invigilator's

belief that two hours have elapsed not itself a reason for her to act, but also there is a way of justifying her behaviour (one that she fails to act by) that operates quite independently of what her belief is.

This raises the interesting question of whether someone may have reasons for acting that are completely independent of *any* aspect of their psychological state. Might someone have a reason to act one way even though the system of justification that provides that reason has no link whatsoever with any aspect of that person's motivational structure? This is one of the questions that Bernard Williams considered in his paper "Internal and External Reasons" (1981: ch. 8). And his conclusion is that such a notion of reason would be quite empty.

He accepts that you might have a reason for acting even though you do not believe that you do. The invigilator has a reason not to stop the exam even though she does not realize this. He also accepts that you might have a reason to do something even when you do not want to do it. You might not want something that you should want.

For example, suppose I do not want to work really hard to achieve the goal of getting a good degree. Later on, when I have wasted a lot of time and at the same time not got a good degree, I think I should have wanted to get a good degree. By the same token I come to realize that the fact that one needs to work hard to get a good degree was a reason for me to work hard. Although it was a reason for me I did not realize this and did not act on it. My not having the relevant desire at the time may explain why I did not realize I had a reason to work hard, but it does not mean that I did not have such a reason.

In this case I may come to realize that even back then I had a reason to work hard. I come to realize this through a process of articulating a conception of who I was – what sort of person I was – and reorganizing my past goals and commitments in the light of this new and clearer self-conception. The process may require imagination as well as learning by experience what it is to be a certain sort of person.

It is not merely a process of working through the implications of what I already wanted. But it is a process that is based on some pre-existing motivational structure. For it to be right to say that I had a reason to work hard back then it must be the case that even back then I was committed in my way of behaving to a way of justifying behaviour that when properly worked through (using imagination, experience, etc.) would recommend that I work hard.

Williams's claim is that a person must have some pre-existing motivational structure from which a reason can be derived if it is to count as a reason for them to act. Because I valued the idea of fulfilling one's potential and saw myself as a person with some potential, I should have seen that I had a reason to work hard. According to the motivational structure I had back then there was a reason for me to work hard even though I had not worked it out as such then.

But suppose instead that I had valued above all else membership of some social group, a group whose nature as a forum for having a good time and developing one's experiences of life would have been undermined by working hard on one's degree. And suppose I knew that this was incompatible with being a high achiever, but I genuinely did not care. Then there would have been nothing in my motivational structure that would connect with the idea that getting a good degree was a reason to work hard. And according to Williams this means that I would not have had a reason to work hard. Now in later life I might regret not having worked hard, but I cannot accuse myself of having made a mistake, since there was no reason for me to work hard at the time.

In the same way, as a supporter of the Ireland football team, I have no reason to cheer when England score a goal. And even if I convert to being an England supporter, I will not look back on those times when I was an Ireland supporter and say that I had a reason to cheer when England scored. Something might be a reason for one person to act in a certain way and not be a reason for another person in an externally similar situation to act in the same way. This means that whether or not something counts as a reason for a person to act may depend on certain aspects of their psychology.

As it stands, Williams's claim that a person must have some pre-existing motivational structure from which a reason can be derived if it is to count as a reason for them to act does not commit him to an inward-looking approach to justification. The notion of a motivational structure does not need to be taken to be the same as that of an internal emotional state or a set of desires. We might think of it as simply a commitment to a certain system of justification. Then Williams's claim would amount to something like the following. For a consideration to count as a reason for someone to act it must be a reason according to a system of justification that that person is committed to.[1]

This means that we need not even conclude that there are no universal reasons: reasons that are reasons for absolutely anyone in such a circumstance to act in such a way. Some reasons might follow from any system of justification once it is properly worked out. For example, many philosophers have argued that some *moral* reasons are binding on anyone whatever their beliefs and desires. This is compatible with Williams's claim (although not something Williams himself would have defended) if it can be argued that such moral reasons are an inescapable consequence of any rational starting-point (as Kant would have argued).

If I say that you should care about this person's welfare because she is your daughter, perhaps you cannot escape this reason by saying that you have no commitment to this moral caring stuff. Perhaps it is the case that once you are in the game of justification at all you must be in the game of morality. You do have reason to care about her welfare whatever you choose to think, because we can derive that recommendation using imagination and experience from any rational starting-point you like.

Williams's argument and Hume's argument

Williams presents a different argument for the conclusion that reasons to act must be derivable from the agent's motivational state. I shall introduce this argument with a view to considering shortly Hume's parallel argument for the conclusion that moral reasons depend on the agent's emotional state. Williams's argument goes something like this:

1. When you are motivated to act there must be some motivational state that you are in.

Williams calls this motivational state a motivational set and suggests that we might think of it as a set of desires, although we can think of it in other terms too. I have been suggesting that one way to understand the idea of a motivational state is in terms of a commitment to a particular system of justification.

2. Believing that you have a reason to act by itself means that you are motivated to act.

This does not mean that if you have a reason to act you will necessarily go on to act in that way. Being motivated to act in this context means being in a state that may cause you to act if it is not interfered with; there is something that motivates you to act, although there may be some opposing inclination that means that you will not act.[2]

This assumption often goes by the name of *internalism* since the motivation to act is taken to be *internal* to the belief that you have a reason to act. What is being ruled out by this assumption is the possibility of believing that you have a reason to act in a certain way and yet be completely unmoved by it even though there are no countervailing reasons or forces. The thought is that if someone claimed to be in this position we could say to them that they did not really believe that that was a reason *for them* to act. At best there would be a reason that someone else thinks they have to act.

3. Therefore, believing that you have a reason to act requires that you are in some appropriate motivational state.
4. Therefore *that* you have a reason to act requires that you are in some appropriate motivational state.

I think that (3) follows deductively from (1) and (2). The step from (3) to (4) is a bit obscure, however. The argument presented by Williams is plausible, although not watertight. He asks why, if (4) were *not* true, could an agent with a reason to act but not in the relevant motivational state not come to believe that they have a reason to act, and come to believe that without thereby going into that motivational state?

Rather than worry about this last step I propose to focus on the first three stages of the argument. These stages exactly mirror a very famous argument presented by Hume in his *Treatise of Human Nature*. It is his argument for what we now call *ethical non-cognitivism*: the view that moral judgements cannot be derived from reason alone. For our purposes, its significance is that the central premise of Hume's argument, namely that reason alone cannot motivate action, threatens the outward-looking rationalistic approach to agency of Anscombe and others. It would seem from Hume's argument that what makes something an intentional action must be more than simply its being subject to justification, but must include the influence of desires or other emotions.

The argument goes as follows:

> Since morals, therefore, have an influence on the actions and affections, it follows, that they cannot be derived from reason; and that because reason alone, as we have already proved, can never have any such influence. Morals excite passions, and produce or prevent actions. Reason of itself is utterly impotent in this particular. The rules of morality, therefore, are not conclusions of our reason.[3]

The argument can be paraphrased as follows:

1H. Reason alone cannot motivate you to act; being motivated to act depends on having some passion (i.e. emotion of some sort).
2H. Moral judgements by themselves may motivate you to act.[4]
3H. Therefore moral judgements cannot be derived from reason alone; passion must be involved in deriving moral judgements.

The most obvious difference between this and Williams's argument is that Hume is talking about moral judgements, whereas Williams is just talking about reasons to act. This means that the second assumption – the internalism – is rather more contentious in Hume's argument. But it is Hume's first premise that I want to focus on.

It is also different in an important way from Williams's. Williams's first premise is quite trivial. It is that when you are motivated to act there must be some motivational state you are in. Hume's assumption that reason alone cannot motivate you to act amounts to the claim that passions (i.e. emotions such as desire, greed, love, etc.) must be part of what motivates you to act. In other words, it amounts to the idea that being motivated to act *depends* on having the relevant emotion. The emotion would commonly not be very powerful or noticeable; it might be something like a mild preference. But it must be an independent input to your motivational system from which the behaviour flows.

There are two main arguments that Hume brings to bear (*Treatise*, Book 2, part 3, section 3) to defend this claim. In his central argument Hume assumes that reason is either deductive (concerning demonstration) or inductive (concerning probability). Neither of these can be used to justify an action. So there can be no motivation

of an action in line with a justification of that action by reason; and so an action can only be motivated by something external to reason, that is, desire or some other emotion. But the assumption that reason is either deductive or inductive just begs the question against the sort of conception of reason that I introduced in Chapter 2. There I talked about a system of practical justification as a way of deriving recommendations for action. This system embodies various rules of inference that are neither deductive nor inductive.

Hume's second argument is based on the assumption that reason deals in transitions between abstract representations of the world not between concrete entities in the world. He calls such concrete entities "original existences"; they take up space and get involved in causal processes. Only abstract representations are capable of being true or false or of according to or being contrary to reason. Passions and actions on the other hand are original existences; they have some concrete reality, and get involved in real causal processes. So actions and passions cannot be derived from reason.

Now Hume is right that a system of practical justification, like a system of theoretical justification, is abstract. But an abstract logic can be embodied in a causal process of logical reasoning; and an abstract structure of practical justification can be embodied in a concrete process of practical reasoning. Just how this might work will be considered in more detail in Chapter 5. But that something like this is a possibility seems intuitively clear.

What is captured in the idea of reason motivating action is the idea of an agent, in virtue of being committed to some abstract system of justification, being motivated to act. An abstract system of practical justification cannot give rise to an action all by itself; Hume was right about that. What gives rise to an action is its embodiment in some motivational state of the agent, through the agent's commitment to that abstract system of justification. But this is quite a reasonable way to understand the idea of reason alone motivating action.

Emotions

So Hume's arguments against the possibility of action being motivated by reason alone do not consider the sort of conception of practical justification that I have been discussing. But perhaps there is a simpler argument working behind the scenes as it were and

supporting the surprisingly widespread acceptance of Hume's conclusion.

As I said, Hume's claim is very similar to the first premise in Williams's argument, a premise I took to be trivially true. Williams's premise was that whenever you are motivated to act there must be some motivational state you are in. We might equally say that whenever you are motivated to act you must *want* to act in that way. Wanting to act in some way is having a passion of some sort. So why can we not conclude that being motivated to act depends on having some passion – a desire – and therefore that reason alone cannot motivate you to act?

There is a big jump from saying that you must want to act in a certain way whenever you intentionally act that way to saying that intentionally acting in a certain way *depends* on wanting to act that way. It might be the other way around. The reason you always want to do what you do might be that wanting to do something *follows* from being motivated to do it. Instead of assuming that your motivation depends on your emotional state we might say that your emotional state depends on how you are motivated to act. This is the move made by a variety of philosophers including Kant, Thomas Nagel and John McDowell.[5] This is Nagel:

> Therefore it may be admitted as trivial that, for example, considerations about my future welfare or about the interests of others cannot motivate me to act without a desire being present at the time of action. That I have the appropriate desire simply *follows* from the fact that these considerations motivate me; if the likelihood that an act will promote my future happiness motivates me to perform it now, then it is appropriate to ascribe to me a desire for my own future happiness. But nothing follows about the role of the desire as a condition contributing to the motivational efficacy of those considerations. It is a necessary condition of their efficacy to be sure, but only a logically necessary condition. It is not necessary either as a contributing influence, or as a causal condition. (1970: 29–30)

What Nagel is doing here in turning the relationship between desire and motivation to act on its head is construing desires in a behaviourist manner. What it is to want something is to be motivated to act in a way

to achieve it. This is to understand wanting in terms of a disposition to behave. And the same idea can be applied to other emotions. What it is to respect someone is to be motivated to treat them as worthy of respect, whatever that turns out to be. What it is to be angry with someone is to be motivated to treat them worthy of anger, that is, as having done something wrong that needs to be made amends for.

For each emotion there is a system of justification – a way to behave – that someone capable of feeling the emotion is committed to. Their behaviour is justified emotionally by this system of justification. For example, if you shout at someone who has insulted you you have a reason for shouting at them. The reason is that they insulted you. And being committed to a system of practical justification that justifies your behaviour in that way is to be the sort of person who is liable to take offence.

In general, emotional behaviour is justified behaviour. It is justified by a system of practical justification. Indeed, according to Aristotle, if the system of practical justification that justifies emotional behaviour is properly regulated so that you neither react too quickly to offence nor too slowly and the same with all the other emotions, then emotional behaviour counts as *virtuous* behaviour.

For Hume in the *Treatise*, emotions appear in the mind prior to justification and then feed into the process of motivation with reason merely guiding the will to the target set by the emotions. Whereas for Aristotle (and I think Kant too) emotions are bound up in justification from the beginning.[6] Being motivated to act emotionally involves being committed to a system of practical justification.

There is another side to emotional behaviour that seems less bound up with being motivated to act in a way that is committed to some system of practical justification. This is the bodily aspect of emotional behaviour: crying, sweating, shaking, going red in the face, blushing, eyes dilating, voice quavering, stomach churning, muscles tensing, heart beat rising and so on. These are the *creaturely* aspects of feeling emotions, aspects that do not seem to be so clearly bound up with a system of rational or justified behaviour. Indeed these bodily or creaturely aspects of your behaviour are not really intentional actions at all. Yet they do seem to be a central feature of having the emotions.

Although central they are not strictly essential features. Some emotions do not seem to have bodily aspects, for example, feeling

respect for someone. And the bodily aspects of emotions do not characterize the particular emotions. There may be no bodily way to distinguish fear and anger. I might cry when I am happy or when I am sad. And different cultures have had different attitudes to these creaturely expressions of emotional states, either reviling and controlling them or revelling in them.

I think perhaps the best way to think of such bodily expression of emotion is as a primitive prerational structure of responses to our environment that we still have in virtue of still being animals, and that have become the basis of much more refined and worked out ways of behaving that do involve commitments to systems of practical justification. Grief or anger may have started out in one way with quite automatic bodily responses and have become acculturated, refined and fully justified. The automatic bodily responses are still there worked into the overall conception of how to behave when someone you love dies or someone wrongs you in their behaviour.

Conclusion

In this chapter I have considered two ways in which an agent's reasons for action might depend on their psychological states, in particular on their beliefs and desires. In the first way, an agent's reasons for acting *are* their beliefs and desires. In the second way, an agent's reasons for acting may be external considerations, but they count as reasons for the agent in virtue of the agent's beliefs and desires.

I argued that the rules by which we justify action make reference to external circumstances and not in general to the agent's own psychological states. So the reasons that fit into those rules must be facts about external circumstances and not in general facts about psychological states.

We do, however, justify our actions and make them rationally intelligible by describing our beliefs. I suggested that this apparent contradiction might be explained by distinguishing carefully between reasons that are reasons *for* acting in a certain way and reasons that are reasons *why* an agent acted in a certain way. That an agent had a certain belief is not generally a reason for acting in a certain way, but only a reason why they acted in that way.

Such reasons do not justify what they do, but reveal the system of justification that the agent was committed to in their action and

by which what they do was justified. That she believed that three hours of an exam had elapsed is not a reason for the invigilator to stop the exam; but it is a fact about the system of justification she was employing in her action. According to that system of justification her stopping the exam was justified by, for example, the fact that the exam was supposed to last three hours.

In such cases, the fact that the agent has the belief is not a reason for their acting in a certain way. But it is nevertheless true that they have a reason for acting in that way *in virtue of* having that belief. I then considered whether it is *always* the case that you have the reasons you do have in virtue of having the beliefs and desires you do have. Using Williams's consideration of internal and external reasons, I concluded that only a weaker claim than this was warranted. That is, you only have the reasons you do have in virtue of being committed to the system of practical justification you are committed to.

This means that you would not have the reasons you do have, nor would you be motivated to act in the way you are motivated to act, unless you had the desires and other emotions that you do have. But it does not follow that these desires and emotions are motivational inputs. You might instead have the desires and other emotions that you do have in virtue of being motivated to act in the way you are – and in particular in virtue of being committed to the system of practical justification you are committed to.

It follows that we can acknowledge the necessary connection between intentional action and psychological states without adopting an inward-looking approach to intentional action.

4 Agent causation

Action as a causal concept

Whether the concept of action is a causal concept is a philosophical question that seems so far removed from any real concerns that it may be hard to drum up any interest in it. It is tempting to say "Yes, it obviously is; and so what?" But in fact it is not obvious; and it is important. The answer to this question effectively determines the structure of one's whole approach to the philosophy of action. If the answer is yes, then we have to work out how to characterize the causal nature of action, and by doing this will have moved a long way towards understanding what action is. If the answer is no, then there is a real challenge about where to go from here. How else can we analyse our concept of action; or is it in fact unanalysable?

Action involves transforming the world in certain ways. As such the idea of action appears to be the paradigm of a causal idea. The action of turning on a light involves *making* the light go on. The action of writing a book involves *making* a book get written. So it appears that whenever an agent acts they make something happen. One thing making something else happen is the same as one thing causing another to happen. So action seems to be a *causal* concept; to say an agent is acting is to say that they are causing some result to be achieved.

Not all examples of action, however, so clearly equate to making things happen. What do you make or cause to happen when you go for a walk, eat an apple or phone a friend? Perhaps we can say that you are making yourself go for a walk, making yourself eat an apple or making yourself phone a friend. But not only does this sound

wrong in itself, it does not seem very helpful. Little philosophical progress is made by saying that what it is to phone a friend is to cause oneself to phone a friend. This would be to explain something in terms of itself. In such an account the talk of *making* or *causing* is doing no work at all. This is how Irving Thalberg (1967) argued against the idea that in acting we make things happen or cause things to happen.

If the idea of causing is supposed to be doing any work in the claim that phoning a friend is causing oneself to phone a friend, then there is an unpleasant infinite regress. If phoning a friend is the same as causing oneself to phone a friend then it is also the same as causing oneself to cause oneself to phone a friend, and so on *ad infinitum*. The talk of causing here had better be quite empty, or you are causing an infinitely nested structure of causal processes every time you pick up the phone.

Now, one way to avoid this regress would be to be less ambitious about what a causal account of action is supposed to achieve. So far I have been considering the question of what an action *is*. But there is a less ambitious question that I might have asked; namely, what are we committed to in saying that someone is acting? The first question asks for a *constitutive* theory of action. The second asks for an investigation into the conceptual implications of saying that someone is acting; let us call it a *conceptual* theory of action.

The difference between these two questions may be marked by whether or not it is acceptable to mention acting in the answer. To the constitutive question of what it is to act it would not be acceptable to reply that it is for one's acting to be caused in a certain way. This answer would lead to the infinite regress just outlined. But it would be fine to answer the *conceptual* question by saying that in asserting that one is acting one is committed to the implication that one's acting is caused in a certain way. No circularity or regress looms here.

Consider the matter in symbolic terms. The constitutive theory is this:

$$A = \text{the process of } S \text{ causing } A$$

But this equation for A can be substituted into the right-hand side of itself *ad infinitum*. So A = the process of S causing the process of S causing A. And indeed A = the process of S causing the process of

S causing the process of S causing … the process of S causing A. On the other hand, the conceptual theory is this:

A happens $\Rightarrow S$ causes A (where "\Rightarrow" means "entails that")

Given this, no further substitution is warranted, and no infinite regress occurs.

The other way to avoid the infinite regress would be to go for a more, rather than less, ambitious causal account. This would have to be a more decidedly *reductive* account, in which what it is to act in a certain way is analysed in terms that do not mention acting in a certain way. If acting is to be understood in terms of making something happen, there had better always be something *other than the acting itself* that can be identified as the agent's effect.

But what, if not the action itself, does an agent make happen when they act? I think there are two possible answers to this question: (i) what they make happen is the movement of their body; (ii) what they make happen is the intended result or structure of results. So in the case of phoning a friend we might say (i) that the agent causes their hand, mouth, larynx and so on to move in certain ways, or we might say (ii) that they cause a telecommunication connection to be in place with their friend.

It is important to make the distinction between transitive and intransitive movements of the body.[1] When you move your body in a certain way your body moves in a certain way. And your body moving in a certain way is not the same thing as your moving your body in that way. One is an *intransitive* movement; the other is a *transitive* movement. One does not and the other does essentially involve the agent. Your body moving does not essentially involve *you*, as the very same bodily movement might have been caused quite differently and not have been a case of your moving anything.

According to a causal approach to body movements, when you (transitively) move your body, your body (intransitively) moves as a *result* of your agency. So, in moving your body in a certain way you are causing your body to move in that way. When you raise your hand your hand rises. But your hand rising is not the same thing as your raising your hand. So there seems to be no difficulty in analysing your raising your hand as a causal notion. Your raising your hand is your causing your hand to rise.

Opponents to the causal approach to action might object to this. They might say that the simple idea of raising your hand is quite different from the odd idea of causing or making your hand rise. In normal cases you do not *make* your hand rise; you just raise it. Only in non-standard cases, such as that of autohypnosis, do you cause your hand to rise.

In autohypnosis you might say to yourself: "In a moment your hand will rise up into the air. I do not want you to try to raise your hand. In fact I want you to try to keep your hand down. But the harder you try to hold your hand down the stronger will be the force pulling your hand up. Now when you stop trying to hold your hand down, it will rise up by itself." And so it does. You have caused your hand to rise. In the spirit of philosophical enquiry I have taught myself this skill, and I would recommend it to anyone. Not only do you learn more about agency, you help yourself with all sorts of self-improvements, and you can give yourself excellent techniques for other things, like recalling people's names.

But I think the case of autohypnosis is not decisive against the causal approach. It does seem correct to say in this sort of case that you have made your hand rise or caused it to rise by telling yourself it will rise. But it is not so clear that you have not at the same time raised your hand and indeed tried to raise your hand. You have not raised it in the normal way. But when you say to yourself "Do not try to raise your hand" this may just mean "Do not try to raise your hand in the normal way". The whole exercise is an exercise in trying to raise your hand, in an unusual way. When you have learned this technique you now have two ways to raise your hand: you can either just raise it or you can go through this routine in order to raise it.

Another interesting issue that arises from this sort of example, although it does not bear on the argument about the causal approach to action, is whether when someone else hypnotizes you, perhaps using the very same words, it can be said that *you* have raised your hand. It is often said that no one can hypnotize you to do something you do not want to do. And I think this means that if someone else makes a suggestion to you that your hand will rise, your hand will not rise unless you accept this suggestion: unless you comply with it.

Your hand rises as a result of your compliance with the hypnotist's suggestion. The question is whether this compliance *constitutes* agency. Is it right to describe you as raising your hand in virtue of

your complying with the suggestion that your hand will rise? I am not sure, although I am inclined to say that it is.

Whatever we say about this case of your hand rising as a result of someone else's suggestion, it does seem that when your hand rises as a result of your own suggestion you can be described as raising your hand, albeit in an indirect way. But the opponent to the causal approach might accept that in such cases of autohypnosis you do both raise your hand and cause your hand to rise. What they may insist on is that in *normal* cases of raising your hand, it is wrong to describe yourself as causing your hand to rise.

Now it would certainly be an odd way to talk in normal cases, but that by itself does not make it wrong. Suppose there was something else – say a force field or an electric shock – that might have made your hand rise. Then a sensible question for someone else to ask about your hand rising is "Did *you* make that happen?" And the sensible reply is "Yes, I caused my hand to rise."

Can this causal approach be applied across the board to all actions? It could if all actions were cases of an agent moving their body in a certain way. But although phoning a friend and going for a walk certainly involve moving your body in certain ways, it is less clear that they should be *identified* with moving your body in these ways. Perhaps you do cause your body to move when you phone a friend; but is this causing your body to move just what you are doing when you phone a friend? The problem is particularly obvious for those actions that do not involve moving the body at all. You might work out the answer to some problem in your head, without there being any body movements that are characteristic of this. Yet solving the problem is still an action.

Perhaps we should consider the second answer to the earlier question of what an agent makes happen when they act. This is that they make the intended result or structure of results happen. Often this will be to identify the effect with something other than their body moving. For example, in the case of solving the problem the intended result is the problem becoming solved. According to this causal approach your solving the problem may be understood as your causing the problem to be solved.

This causal analysis has the same structure as the analysis of moving your body. In the transitive action of solving a problem you are causing the intransitive event of the problem being solved. One

challenge for this approach is to show that there must always be an intransitive characterization of the agent's intended effects in any action. The danger is that the apparently intransitive characterizations of a problem being solved, a walk happening, a friend being phoned or an apple being eaten are all really shorthand *transitive* characterizations. A walk cannot happen without someone going on it. So to say that a walk happened is just to say that someone walked. When I say that my intended result when eating an apple is that an apple is eaten, I really mean that it is that an apple is eaten *by me*.

This is by contrast with a body movement where there is no conceptual requirement that there is something moving the body. To say that you are causing your body to move is not the same as to say that you are moving your body. But when you are causing your walk to happen you must be causing yourself to be going on that walk. And this gets us back into the infinite regress.

Perhaps the challenge can be met, but it is not going to be trivial. We might start by saying that a person solving a problem may be understood in terms of that person causing the solution of the problem to be known by them. This will not do by itself, since you can get to know the solution just by asking someone, which is not the same as solving the problem yourself. So we would have to add some further condition about how the state of knowing the solution was caused. A person solving a problem might then be understood in terms of that person causing the solution of the problem to be known to them by intellectual means.

In the same kind of way, what it is to eat an apple is to cause the apple to be ingested through one's mouth into one's digestive system. Equally we might try to understand going for a walk as causing a certain sort of pedestrian locomotion for one's body. Phoning a friend might be understood as causing a certain sort of connection to be in place with the friend's phone.

Now the accounts as stated here would need to be refined, and if this sort of causal approach is going to work a lot of effort is going to be required to characterize the intransitive intended results caused by agents when they act. Also these accounts sound like caricatures of philosophical gobbledygook. They analyse perfectly comprehensible talk of eating, phoning, walking and so on into much less easily understandable talk. Far from explaining our talk of action, this kind of causal approach seems to obfuscate it.

The point applies quite generally to all so-called causal concepts. In this respect your eating an apple is just like the concept of the wind breaking a branch, the rain flooding a river, the cooker heating up a chicken, one planet attracting another, or water dissolving a sugar cube. According to a causal analysis, the wind is causing the branch to be broken; the rain is causing the river to be flooded; the cooker is causing the chicken to be heated up; one planet is causing the other planet to be attracted to it.

These analyses, which describe *causing* are much more artificial and difficult to grasp than the original formulations, which describe flooding, heating and so on. Talking about the rain flooding the river is much more natural than talking about the rain causing the river to be flooded. This may suggest that the notion of causation is less fundamental than the various causal notions: acting, breaking, flooding, heating, attracting, dissolving, etc.[2]

Just because we find it easier to grasp descriptions of eating, phoning, breaking, heating, dissolving and attracting than descriptions of causing things to happen, it does not mean that we cannot provide a useful philosophical *theory* of what eating, phoning, breaking, heating, dissolving, attracting and so on have in common that appeals to the general notion of causation. You can learn what eating an apple is by learning that it is *this* sort of thing, and knowing how to tell whether something is or is not a case of this. But there is still a respectable philosophical job to be done in articulating what *this sort of thing* consists in.

To conclude, I think it is a perfectly reasonable philosophical position to deny that acting should be understood in terms of causing something to happen. Certainly it is not something that should be assumed without question. However the causal approach does look like a useful starting-point in attempting to tease out and theorize about what goes into our concept of action. For now, I shall just make the assumption that acting should be understood in terms of causing something to happen, and move on.

The causal theory of action

Most philosophers of action have been uneasy resting with the idea that the causal aspect of action should be understood in terms of an *agent* making something happen. They have preferred to think of an

agent making something happen in terms of some event *in* the agent or state of the agent making something happen. The assumption is that we should understand the idea of a person making something happen in terms of something *in* or *of* that person (usually their mental state) making something happen. Accepting this assumption is to understand agency in terms of people's intentions, decisions, acts of will, acts of trying, beliefs, desires, reasons, dispositions and so on making things happen.

The assumption can be captured in the transition to the third statement in the following series:

A I (deliberately) buy some milk.
B I (deliberately) cause the structure of events characteristic of milk being bought by me.
C My state of mind causes the structure of events characteristic of milk being bought by me.

This assumption is very often called the *causal theory of action*. But the title is misleading. The assumption that I have been considering so far in this chapter, that we can make the transition from (A) to (B), captures the idea that action is a causal notion. It is a further question whether this causal nature of action should be understood in terms of something other than the agent doing the causing. The so-called causal theory of action asserts that it should be.

There are many ways of making this assumption, and for each of them a different version of the causal theory of action. I shall consider some of the variations shortly. But in order to have something a bit more focused, let me present one version here.

When an agent intentionally φ-s their wanting to φ causes their body to move in a way that happens on this occasion to constitute φ-ing.[3]

The issues that arise straightaway from the causal theory of action are the following:
(i) What – if not the agent themselves – should count as the cause when an agent acts? Is it something in the agent's mind, and if so what sort of thing? The version above takes it to be the agent's *wanting* to achieve some result, but this is open to question.

(ii) Is there really a causal relation between such states and the body movements or other characteristic events of the action?

(iii) Is the causal theory an *analysis* of agency? Is the idea of some state or event in the agent making something happen conceptually more fundamental than the idea of the agent making something happen?

(iv) How should the causal relation itself be understood?

(v) Is the existence of such a causal relation a *sufficient* condition as well as a necessary one for action? If not, can it be augmented to become one?

I shall consider the first three of these issues in Chapter 5 and the last two in Chapter 6. First I shall consider the prospects for rejecting the causal theory altogether, while holding on to the original assumption of identifying an agent's doing something with their causing something to happen.

Agent causation

One brave way to resist the causal theory of action is to appeal to the theory of *agent causation*. This theory holds that an agent causing something to happen is a special kind of causation quite different from the sort of causation – call it by contrast *event causation* – that characterizes inanimate processes, and is irreducible to such causation.[4]

Why I call this theory *brave* is that it regards the process of an agent causing things to happen as being outside of the normal scientifically tractable world of natural processes. This contradicts the naturalistic scientific worldview according to which everything fits into the scientifically tractable world of natural processes. Different philosophers, however, mean different things by agent causation, and they vary as to the degree to which they seem to conflict with the naturalistic scientific worldview.

Aristotle talked about agents as causes. He described the builder as the cause of the house (or of the process of the house being built). But this did not commit him to thinking of such causation as different from normal or natural causation. He was just as happy to talk of the seed causing the plant (or the process of growth of the plant).

Aristotle argued that things (including inanimate objects as well as

agents) had powers. Such powers were not taken to be mysterious or magical things. They were the stuff of science: the power of a moving body to impart its motion to a stationary body it hits, the power of water to dissolve salt and so on. And these powerful things caused other things in virtue of the realization of these powers. So, for Aristotle, a thing causing something may be understood in terms of some power in the thing or the realization of that power causing something. In this way he would not have accepted the theory of agent causation as such; he had no difficulty with understanding agents causing things in terms of *aspects* of those agents causing things.

Thomas Reid is usually cited as the first philosopher to argue for agent causation in the stronger sense. Although he was fighting a rearguard action on behalf of Aristotelian philosophy against the modern empiricists such as Locke, Berkeley and Hume, his approach to agent causation went much further than Aristotle's. In his *Essays on the Active Powers* not only did he defend Aristotle's idea of causal powers, which had been coming under attack from these empiricists, but he also argued that the realization of an agent's active powers involved a different sort of causation from that involved in the rest of nature.

Reid's approach to agent causation can be captured in two claims (neither of which comes from Aristotle):

(i) an agent's causing something should not be understood in terms of something other than the agent – for example one of their states of mind – causing something;

(ii) an agent's causing something involves a fundamentally different kind of causation from inanimate causing, whether by events or by inanimate objects.

The first of these claims has been argued for in more recent times, especially by Richard Taylor (1966). What motivates his and many other philosophers' rejection of the causal theory of action is their suspicion that the agent gets lost in such a theory. Whereas it is possible to analyse the claim that someone perspired in terms of an account that does not mention them as such, except as being the person whose body is involved in the perspiration, it is not possible to do the same for the claim that someone moved their finger. Any such attempt would lose the fact that the moving of the finger is an

action rather than merely an event occurring in someone's body. Once you lose the agent from an account of action it stops being an account of action at all. Taylor concludes that the idea of my causing something should not be understood in terms of something other than me, some event, process or state, causing something.

Another version of this sort of argument concerns free will. If action involves your body being pushed around by something other than you – some states or events within you – then it looks as though they are in charge and not you. For action to be properly yours it must be you who is the causal originator of the action rather than these states or events. This is the way that another key proponent of agent causation, Roderick Chisholm (1966), argues.

Now, while it is true that many philosophers defending a causal theory of action talk of beliefs, intentions and so on as though they were entities within a person's mind – somehow identifiable separately from the person – this way of describing mental states is unnecessary and mistaken. It is a mistake especially characteristic of the British empiricists such as Locke, Berkeley and Hume, whose conception of a person's mental life consisted in Ideas passing through a person's mind, a conception in which the person themselves is inessential. But your states of mind are not states of your mind; they are states of you. When you believe and desire things these are states that you are in mentally. It is not your mind or your brain that is in the state of believing. So when these states cause things it is more fully *your being in these states* that causes things.

The picture of your states pushing your body around should not involve you as fundamentally separate from the process, somehow alienated by your own action. That they are *your* states doing the work means that you are centrally involved. Talk of beliefs, desires, intentions and so on makes it seem as if these are self-standing entities. But your belief is really your state of believing something, and we cannot identify a thing's states independently of the thing itself.

So this argument for the theory of agent causation fails as long as we avoid too simplistic a conception of a *state of mind*. We can accept Taylor's claim that any account of what it is for an agent to cause something must make reference to the agent and at the same time allow that it is the agent's being in a certain state that causes something. Saying that the agent's being in a certain state causes something is to make reference to the agent in citing the cause.

Reid argues for claim (ii) above by arguing that only beings with a will have active power properly understood: "Power to produce an effect, implies power not to produce it. We can conceive no way in which power may be determined to one of these rather than the other, in a being that has no will" (*Essays on the Active Powers*: essay 1, ch. 5). So what distinguishes agent causation from other sorts of causation is that the power that is realized in an agent when they cause something is a power to cause or *not to cause* some result. The realization of the power to act, unlike that of an inanimate power, does not determine some result to happen; instead it may result in different possible results depending on the agent. This is what is supposed to distinguish it from inanimate causation. And it is also what is supposed to enable the idea of agent causation to make space for the idea of free will.

It is also this that makes the idea so obscure. According to this idea the same agent with the same powers might or might not cause some result. And whether they do or not does not depend on any other factors, or else those other factors would be engaged in a non-agent causal deterministic explanation. It seems, then, arbitrary that one result rather than another should result from the agent's powers.[5]

It should be stressed that this conception of agent causation is not merely committed to the idea that the powers realized in human action are different from any powers realized elsewhere in nature. This conception of agent causation takes the *way* those powers are realized to be different; they are realized in an *indeterministic* way not found elsewhere in nature. Now, quantum theory has taught us that nature is not deterministic, but involves randomness. But the indeterminism of agent causation is not supposed to be the same as randomness. And this makes for a fundamental metaphysical distinction between the two kinds of causation.

It is this fundamental metaphysical distinction that makes philosophers attack agent causation in the same terms that they attack Cartesian dualism. It is metaphysically dodgy. For one thing, is it not implausible that the fundamental metaphysical category of causation should work one way in the whole of the universe and then work differently in just one kind of process in one corner of the universe, the process of human action?

This charge of metaphysical dodginess is even easier to make against Chisholm's version of agent causation. In addition to the two

claims above he claims that: "there must be some event A, presumably some cerebral event, which is not caused by any other event, but by the agent" (1966: 20). Not only is the causation of that event by the agent non-deterministic but there is no other causal process resulting in it which is deterministic. So the agent-causal process does not emerge from an underlying structure of deterministic event causation, but *interrupts* the underlying structure of event causation. This makes agent causation thoroughly super-natural. According to agent causation, if you looked at the neurophysiological processes explaining brain events you would find a gap, a brain event occurring in a way that could not be causally explained by any other events. This is where the agent intervenes. This is the same commitment that Descartes's dualistic picture makes, and is equally implausible in the light of modern science.

There is another argument against agent causation that was articulated by C. D. Broad long before Chisholm and Taylor came along. He wrote: "How can an event possibly be determined to happen at a certain date if its total cause contained no factor to which the notion of date has any application? And how can the notion of date have any application to anything that is not an event?" (1952: 215). When a person makes something happen – say they make their toes wiggle – they make it happen at a certain time. This means (according to Broad's argument) that they determine it to happen at that time. If we assume that the toes' wiggling is determined by its cause then there must be some aspect of the cause that links up with that particular time. But the person themselves is not a dated entity. A person exists – the very same thing – through time. So just by identifying a person you do not identify something that could determine a dated event.

One way to respond to this argument is to deny that causation involves determination.[6] On this way of thinking an agent may cause their toe to wiggle at 3.00pm but not determine that it does. And this response fits with the idea that agent causation is a special indeterministic sort of causation. Failing this response, it does seem necessary to include in the cause something other than the agent themselves: some aspect of the agent that has a temporal dimension that can link up with the temporal aspect of the effect.[7]

Conclusion

On the face of it it seems right to say that acting is making things happen; it is transforming the world in some way. Yet it is not a trivial issue to determine what it is you make happen when you act. Is it a movement of your body? Or is it some intended result in the world outside your body? Take an action such as that of declaring your love to someone. Although you do make your body move when you do this, it seems inadequate to *identify* what you are doing with making your body move. So perhaps your action should be identified with your making a declaration of love happen. But it is very difficult to see how to characterize this result except by reference to the action of declaring your love, which would be circular.

Athough it is difficult to characterize the result in such cases without circularity, it may not be impossible. And it constitutes a reasonable philosophical programme to work out how to characterize actions in this way. This programme coincides with the causal approach to action. If we embark on this programme the next issue to face is whether the idea of making something happen should be understood in terms of some aspect of the subject – some state or event – making something happen. In Chapter 5 I shall consider this strategy, also known as the causal theory of action.

In this chapter I have considered an alternative strategy: that of treating the idea of an agent making something happen as basic: not to be understood in terms of some state or event making something happen. It is a complex issue and there are many different ways to flesh out the idea of agent causation. I have suggested that one motivation for accepting agent causation – namely, that it leaves space for the role of a free agent in action – is not very clear. I have also suggested that it is a high price to pay if agent causation means that the category of causation is taken to work in one way in the whole of the universe outside of human agency and work in a different way when it comes to human action.

In Chapter 6 I shall consider an approach that has something in common with both agent causation and the causal theory of action. In this approach someone making something happen is not to be understood in terms of a simple causal relation between an aspect of that person and some result. It is to be understood in terms of the realization of a mechanism or potentiality in that person to achieve a certain sort of result in different circumstances. I shall claim that the

real job in characterizing action is not so much that of working out how to characterize the cause – the agent, their psychological state and so on – and the effect – the body movements, the occurrence of intended results in the world and so on – but is that of describing *how* the result is caused: the *process* of acting in a certain way.

5 Mental causation

Psychological versions of the causal theory of action

In Chapter 2 I introduced the idea running through the work of Aristotle, Kant, Anscombe and Davidson, to name a few, that explanation of action involves justifying that action or making it rationally intelligible, and that the appropriateness of such an explanation is a conceptual requirement for talking about action. I talked about justification rather than just about making actions rationally intelligible, arguing that reasons *for* acting justify action in a weak relativistic sense. But I also suggested in Chapter 3 that some facts, while not counting as reasons for acting, may reveal *how* the action is justified; they may be facts about what system of justification applies to the action.

Presenting such a fact makes an action rationally intelligible without justifying it; it provides a rationalization, to use Davidson's term, not a justification. I argued that psychological facts – facts about the agent's beliefs and desires and emotions – fall into this category. They make action intelligible by revealing how the action is justified without themselves justifying the action. This chapter is concerned with the role of such psychological states, so I need to consider the wider category of rationalization in addition to the narrower one of justification.

Davidson, unlike Anscombe, also argued that this rationalizing explanation was *causal*. In other words, reasons for action or reasons that more generally revealed the intelligibility of an action were at the same time causes of action. This leads to the following sort of causal theory of action:

An agent may be said to act intentionally if and only if the characteristic results of that action (whether these be body movements or other intended results) are caused by the agent's reasons for doing it or, more generally, by reasons in the light of which the action is intelligible.

According to the psychological belief–desire conception of practical rationality that I examined in Chapter 3, the only reasons you can have for action are your own psychological states: your desires and beliefs. Whereas you might think that your reason for going to the shop is that you have run out of milk, it is claimed that really your reason must include the fact that you *want* some milk. Also, rather than being the *fact* that you have run out of milk, your reason is taken to be your *believing* that you have run out of milk.

On this conception, practical justification is taken to be a matter of doing what you *believe* will best lead to what you *want*. Combining this psychological conception of practical justification with Davidson's characterization of action as involving causation by reason leads to a psychological version of the causal theory of action. In this version of the causal theory of action, an agent's intentionally doing something is to be understood in terms of their desiring or wanting something, their believing that some bodily movement or other achievement is the best way to satisfy that desire, and for this desire and belief to cause that bodily movement or other achievement.

There is good reason to be wary of this psychological conception of practical justification, for, as I argued in Chapter 3, acting in a justified way involves responding appropriately to the way the world is, and this is not primarily a matter of responding appropriately to your own mental state, although sometimes it may be. Your being in the psychological state of believing that you have run out of milk is not itself a reason for shopping. What is important is whether or not you actually have run out of milk; this is what *justifies* going to buy some more. [So when you work out rationally what you should do, you do not look inwards at your psychological state and act accordingly. You look outwards at the situation outside and act accordingly.]

Even if one accepts that practical justification trades in something other than the subject's own psychological states, it is an attractive idea that beliefs and desires do *rationalize* action in some way. They make it intelligible even if they do not justify it. So, even if it is not

quite right to say that the reason that you are responding to in going to the shop is that you are in a certain psychological state, it still seems right to say that your action was rational *in the light of* your belief (even when the belief is false).

This is certainly the way that Davidson seems to have argued in "Actions, Reasons and Causes". He claimed that we may see what an agent does as reasonable by characterizing him or her as: "(a) having some sort of pro attitude [i.e. a desire, urge, moral view, etc.] towards actions of a certain kind, and (b) believing (or knowing, perceiving, noticing, remembering) that his action is of that kind" (1980: 3–4). For example, when you went to the shop, your action was reasonable in the light of your believing that what you were doing was a case of going to the shop and your desiring to go to the shop. Davidson may not be appealing to the crude conception of practical justification in which the only reasons you have for acting are your desires and your beliefs about what best satisfy those desires. But he does claim that it is always possible to see what is reasonable about an action by identifying an appropriate belief and desire.

Thus using Davidson's conception of acting for a reason, we can arrive at a psychological version of a causal theory of action. Here is a quick version of the argument.

1. All cases of intentional action involve the agent's action being explained by a reason.
2. Such explanation is causal; it explains why the event of the agent's acting that way happened.
3. Even if the fact that an agent has a certain belief and desire is not itself a reason for their acting in a certain way, it is a reason *why* they acted in that way, as it makes their action rationally intelligible.
4. So, in all cases of intentional action, the event of the agent's action is caused by a certain belief–desire pair.

The argument is by no means watertight. Even accepting the three premises, there is room to deny the conclusion. We might think that one sort of reason – a non-psychological reason – causes action, while another sort of reason – the belief–desire pair – merely shows the light in which the action was reasonable without causing it. So we might accept that reasons cause action and that psychological

states are reasons of a sort, but think that they are not the reasons that cause action.

By capturing the rational intelligibility of action in terms of the psychological states of belief and desire, however, Davidson provides an attractive way of seeing how reasons could get involved in causal processes. A belief–desire pair may seem a more plausible candidate for a cause in a causal theory than a distant fact or abstract rule. The fact that you have run out of milk seems to have causal relevance only in terms of the causal relevance of the internalization of that fact in your state of belief.

Not everyone accepts this conclusion. I have argued against it myself (Stout 2004). Abstract rules of justification are certainly not inputs into an agent's process of acting, but they can be thought of as *structuring* such a process. And although it will always be true that an agent has the relevant beliefs and desires when they act accordingly, I argue that these beliefs and desires should not be thought of as inputs into the process of their acting either. But despite this, the overwhelming trend is to couch causal theories of action in psychological terms. [It is widely accepted that to get involved in the causal process of acting an agent's reasons must be internalized as psychological states. It is accepted that what is doing the causal work is not some distant or abstract reason, but the agent's psychological acknowledgement of that reason. *Motivating* reasons are taken to be psychological states.]

Much of the work in current philosophy of action is dependent on accepting a psychological version of a causal theory of action. And philosophers who do not stress the role of reason in action are even more likely to favour such a theory. Alfred Mele has described the central task of the philosophy of action as the "exploration of the roles played by a collection of psychological states in the etiology [i.e. causal history] of intentional behaviour" (1992: 3).

The sorts of questions commonly asked given this conception of the philosophy of action are the following: what exactly are the essential psychological components of action? Must the agent believe that they will achieve the goal they are intentionally achieving? What kind of thing is the desire that must be present? What constraints are there on the sort of causal route from psychological states to behaviour that counts as action? And one of the biggest debates in this area is whether psychological states such as beliefs, desires, intentions or

whatever is supposed to go at the front end of a causal theory of action do really cause the actions, body movements, intended results or whatever is supposed to go at the back end of a causal theory.

Argument from the special role of action explanation

On the face of it it seems pretty obvious that beliefs, desires and intentions do make us act. My wanting an ice cream is at least part of what made me try to get one, and my trying to get one also made my body move along with other results outside my body. We cite psychological conditions in explaining why people do things and in explaining why their bodies move, and these psychological explanations tell us something about what *made* the people act that way and what *made* their bodies move that way. But there are some ways to attack this. The first focuses on the fact that explaining an action rationalizes it (reveals it to be rationally intelligible). This is a very different sort of explanation from most causal explanations of natural phenomena. Generally we think of the task of rationalizing something to be a different task from that of causally explaining it: saying why it happened. In rationalizing something we are revealing the light in which it is rational or justified. We are putting it in the context of the factors that mean it is rational.

It is important to see that not all explanation is causal. If I explain why a painting is beautiful I am not explaining what made something happen; I am showing what it is about the picture that makes it right to describe it as beautiful. This is the same for explaining why a certain move in chess is illegal, why the square root of 2 is not a rational number, or why the causal theory of action is right or wrong. We make these things intelligible without saying anything about a causal process that brought them about.

Making something intelligible by rationalizing it seems to be another such example. Showing the factors that rationalize an action is like explaining why a certain move in chess is right or wrong. It does not appear to involve looking at the causal process leading up to it.

Many philosophers in the wake of Wittgenstein and Ryle have argued this way. A good example is Alfred Melden:

> How then does citing a motive explain an action? Certainly, with respect to the instance we have been describing [that is explaining

someone's raising their hand in order to signal], stating the motive is not offering a (Humean) causal explanation of the action. The explanation does not refer us to some other event – the motive – which explains causally how the action comes to be. … But as we have seen, the explanation of the action given by the statement of the motive or intention explains in a two-fold way: first it provides us with a better understanding of the action itself by placing it with its appropriate context; and, second, it reveals something about the agent himself. (1961: 102)

Davidson's article "Actions, Reasons and Causes" was in part a response to Melden and others. As I explained earlier, he accepted the central idea that explaining action involves rationalizing it. But he argued that such a rational explanation is at the same time a causal explanation. He argued that for any particular action there might be more than one rationalization. For example, your going to the shop might be rationalized in terms of your desire for milk or in terms of your need for eggs or in terms of your desire to chat with the shop assistant and so on. But not all of these rationalizations provide the reason that is the one for which you went to the shop. You could have gone because you needed eggs, since indeed you did need eggs. But you did not go for that reason, but because you wanted milk.

Davidson argued that the only thing that distinguishes the rationalization that provides the actual rather than merely potential reason why you did something is that that rationalization is implicated in the causal process that results in your actually doing it. Saying that you wanted milk does not merely provide a rationalization of your going to the shop; it also says something about what made you go to the shop. [It appears that in asking for an explanation of an action as well as asking for a rationalization we are asking *why that action happened*; and that is a causal question.]

Are actions events?

A response that anti-causal theorists sometimes make to this is to observe a grammatical confusion at the heart of this way of talking.[1] They say that when you provide a causal explanation of why something happened you are explaining why an *event* happened. But when you justify what someone does you are not justifying an event

happening; you are justifying *what they do*, and that is a different sort of thing altogether, although easily confused.

Suppose I open a window because the room is stuffy. Something happens here; namely, the event of my opening the window. And this event may be explained causally. But it would be wrong to say that the room being stuffy is a reason for that event to happen. It does not justify the event happening. What it justifies is my opening the window; and this is not something that happens, but something I do. I do not do an event; I do an action. So actions are not events. They are not the sorts of things that can be causally explained. Perhaps they are not concrete particulars at all.

I think the causal theory of action can respond to this. Whenever someone acts there is some event or happening: the event of their acting that way. It is not this event that is justified or rationalized in an explanation of action; the anti-causal theorist is right about this. What is justified or rationalized is not the event that happens but the action that is done. But this does not rule out the justification or rationalization of what is done figuring in a causal explanation of the event of its being done. The psychological states that rationalize *what you do* can at the same time causally explain *the event of your doing it*. And this is all the causal theory requires.

If the causal theory has constitutive ambitions, it will not claim that the rationalizing psychological states causally explain the event of your *action* as such, but that they causally explain your body moving or the intended results of your action being achieved. And the same move may be made here. The states that rationalize your moving your body in a certain way or your achieving certain other results causally explain the event of these movements or results happening. This is a perfectly good proposal for how reasons and causes come together in action.

Do beliefs, desires and intentions cause things?

Another anti-causal argument works at the other end of the causal theory. It claims that when we explain action the thing that makes the action intelligible is not the sort of thing that may count as a cause. In other words the psychological states of believing, desiring, intending and so on are not the sorts of things that make other things happen. Indeed, perhaps they are not *things* at all.

The simplest version of this argument observes that beliefs, desires and intentions are *states* of mind rather than *events* and claims that events are the only things that figure in causal relations. States do not have an active existence and so cannot make other things happen. Ryle presented this version of the argument as follows:

> There are two quite different senses in which an occurrence is said to be "explained". ... The first sense is the causal sense. To ask why the glass broke is to ask what caused it to break, and we explain, in this sense, the fracture of the glass when we report that a stone hit it. The "because" clause in the explanation reports an event, namely the event which stood to the fracture of the glass as cause to effect. But very equivalently we look for and get explanations of occurrences in another sense of "explanation". We ask why the glass shivered when struck by the stone and we get the answer that it was because the glass was brittle.
>
> (1949: 88)

According to Ryle, saying that someone believes something or wants something is to say how they are disposed to behave just as saying that a glass is fragile is saying how it is disposed to behave. And in both cases you are not describing something that can make other things happen. But I do not think that this is a very deep challenge to the causal theory of action. There are at least two possible responses. One is simply to allow states to be causes. The other is to find corresponding events that may stand as the causes. This response was presented by Davidson. Davidson accepts that states such as beliefs and so on are not causes, and that only events are causes. So he adapted the causal theory so that instead of having beliefs and desires causing body movements, he had the *onslaught* of beliefs and desires causing body movements (1980: 12). Instead of having intentions in the causal theory he had the events of coming to have intentions.

A deeper version of this anti-causalist argument is to deny that describing someone's beliefs, desires, intentions and so on is to describe real states at all. This is often taken (I think wrongly) to be what Wittgenstein and Ryle were claiming. Before you say that you *believe* that Australasia is the smallest continent, you do not look within yourself; you are making an assertion about Australasia not

about yourself. When you say that you intend to go to the party tonight you are not thinking about what is going on inside you, but about what you will actually do. So it might be thought that beliefs and intentions are not real states of a subject at all.

We need to be careful, however, not to jump from the fact that describing your belief about Australasia involves you in making some commitment about Australasia itself to the claim that it does not also involve you in making some commitment about your own psychological state. When you describe someone else as believing that Australasia is the smallest continent you are making the same sort of claim as when you describe yourself as believing that Australasia is the smallest continent, but you are not in that case making any claim about Australasia. And when you say what someone else intends to do or wants to do you can only really be describing *their* state.

The logical connection argument

Another argument that Davidson responds to in "Actions, Reasons and Causes" is the logical connection argument.[2] According to this argument there must be a proper separation between cause and effect. The cause must be distinct from and prior to its effect. But beliefs, desires, intentions and so on are not properly separate from the actions they are supposed to explain. So beliefs, desires, intentions and so on do not cause actions.

There are two ways in which psychological states are logically connected with actions. The first follows from the causal theory of action itself. What happens when someone acts would not even count as an action if the agent did not have the appropriate intention. So the very existence of the supposed effect logically implies the existence of the supposed cause. The second way that psychological states are logically connected with action is that it would not be right to describe someone as intending to do something in particular if in suitable circumstances they did not go on to do it. If I say that I intend to give up smoking this very minute and never have another puff and at the same time light up a cigarette, it is clear that I did not really intend any such thing. If you really have such an intention then there are logical implications for your actions. So the existence of the supposed cause in the causal theory of action has logical implications for the supposed effect.

Davidson's treatment of this argument is devastating. He rightly accuses it of conflating logical connection with actual (physical) connection. It may be true that a cause must be physically separate from its effect. But this has nothing whatsoever to do with logical connection. Logical connection depends on how things are described, not on their actual natures. And for any events at all it is possible to come up with descriptions that make them logically connected and other descriptions that make them logically unconnected.

Consider the claim that the assassination of Archduke Franz Ferdinand caused the outbreak of the First World War. This claim may or may not be true; suppose it is true. The two events are certainly physically separate from one another. They are also logically separate described in that way. But we can easily describe them in ways that make them logically connected. For example, that very same event – the assassination of the archduke – can be described as the primary cause of the First World War. Now it is true, although uninformative, to say that the primary cause of the First World War caused the First World War. The causal relation that is being asserted is the very same one as in the original claim. But this time there is logical connection. The existence of the primary cause of the First World War logically implies the existence of the First World War. This is because it would be false to describe that event – the assassination – as the primary cause of the First World War if there were no First World War. Such a redescription of the event, however, does not mean that now the event is *physically* inseparable from the event of the outbreak of the First World War. The first event still causes the second event. [In just the same way the decision to act may be taken to be physically separate from the action itself, even if there is a logical connection between them so described] And this means that a causal connection cannot be ruled out.

This response to the logical connection argument depends on the supposed causes and effects in the causal theory of action having identities independent of their logically connected descriptions. And this may be questioned. Von Wright (1971: 94) claims that the supposed cause in a causal theory of action – say an intention – cannot be *defined* without reference to its supposed result. One cannot identify that an agent has a certain intention without finding out that the behaviour is of the appropriate type. So he is not just saying that we can describe an intention and its supposed result in such a way

that there is a logical connection. He is saying that any descriptions that *define* or *identify* them must involve a logical connection. And this does seem to threaten the idea that they are causally connected.

Let me try to make this argument a bit more rigorous. First, we can stipulate a definition of an *essential description*. If a description, D, is an essential description of something, e, then e could not exist unless D described it, and there is nothing more to e's existence than that. So e exists only if D applies to it, and D cannot apply to anything else. For example the description "that strand of hair" applies to a particular strand of hair, and there is nothing that might happen to the hair so that the description would fail to apply to it. It could not stop being a strand of hair; otherwise it would stop existing. Likewise, nothing else could be correctly described as that strand of hair.

This is by contrast with a description such as "the first man on the moon". This description applies to Neil Armstrong, but Neil Armstrong would still exist if that description failed to apply to him; and it is not impossible for that same description to apply to someone else altogether. So "the first man on the moon" is not an essential description of Neil Armstrong (the first man on the moon), whereas "that hair" seems to be an essential description of that hair.

[Here is how the idea of an essential description may be used to bolster the logical connection argument. If D_1 is an essential description of c and D_2 is an essential description of e, and D_1 logically entails D_2, then c could not exist without e existing. And this means that c cannot be a cause of e. Equally, if D_2 logically entails D_1, then e could not exist without c existing and again c cannot be a cause of e. If the descriptions that figure in a causal theory of action are logically connected and they are essential descriptions, then the causal theory is in trouble.]

Now it is certainly too strong a claim to say that intentions and actions cannot be described in such a way that they are not logically connected. I might describe my intention to rob a bank as the intention I have been discussing with my collaborators. This description is not logically connected to the description of my robbing the bank. But describing my intention that way does not get to the essence of it. It would be precisely the same state of mind even if I had not been discussing it with my collaborators. But would it be precisely the same state of mind if it were not the intention to rob a bank?

Davidson accepts an identity theory of mind according to which every mental state is identical to a particular brain state, although he thinks there is no way of linking *descriptions* of mental states and *descriptions* of brain states. So in Davidson's system there is no objection to the idea that a mental state such as the intention to rob a bank, which happens to be identical with a certain brain state, might exist in another context – perhaps a world in which banks did not exist – and in this different context not be properly described as an intention to rob a bank. So to describe a certain intention as a certain sort of intention is not to provide an essential description.

For Davidson, intentions can be identified independently of identifying their supposed effects. They can be identified as brain states. But this is a very contentious claim, and one that anti-causalists are certainly entitled to question. They might say that the one thing that is essential to the intention to rob a bank is that it is the intention to rob a bank. And it has no possible identity independently of this.

The anti-causalist must make the same move at the other end of the supposed causal process. They will claim that the action or its characteristic results is not identifiable independently of its description in the terms that make a logical connection with the intention. In particular they will reject the claim that an action or its characteristic results can exist except as an intentional action or intentionally achieved results. They will deny that an intentional action's results could occur except as part of an intentional action. For example, the body movement that is involved in my raising my hand is a different body movement from that of my hand rising non-intentionally. It might look the same superficially, but the intention that is present in one of these movements is essential to it, according to the anti-causalist.

So here is one way that the anti-causalist may argue. There is nothing I do when I raise my hand that could exist without my having the intention to do that raising of my hand. There is no possible situation in which some other state of mind could be described as being the intention to do that raising of my hand. So what I do could not exist without that state of mind existing. The two are not just logically connected; their existences are connected. And this means that one cannot be the cause of the other.

There are quite a few controversial assumptions in this argument. But at any rate, it does not depend on some absurd mistake to fail

to distinguish logical connection from connection in existence. An anti-causalist such as von Wright argues that describing an intention as such and describing an intentional action or intended achievement resulting from an action as such are defining what these things are. Their identities cannot float free of these descriptions. In this case logical inseparability means real inseparability, which is incompatible with a causal relation.

Is the causal theory of action really a *theory* of action?

Even if it is a necessary condition of intentional action that psychological states cause body movements or other intended results, this does not mean that the causal theory works as an explanatory theory of what action is. For one thing, as we shall see in Chapter 6, the causal theory, as usually construed, does not provide a sufficient condition for action even if it provides a necessary condition. Indeed, even if the causal claim were made part of a set of necessary and jointly sufficient conditions for action it would not follow that the causal claim were part of an explanatory account of action.

It is a necessary and sufficient condition of an animal being a cow that its meat should be beef, but this condition forms no part of an explanatory account of what it is for an animal to be a cow. It is a necessary and sufficient condition of a number being the number 2 that that number is the positive square root of the number 4. But it is no part of an explanatory theory of what it is for a number to be the number 2 that it should be the positive square root of 4. Some further requirement must be met about priority in theory or understanding. I can know what the number 2 is and understand claims about it without knowing that it is the positive square root of 4 or even understanding what a square root is. But I do need to know that 2 is the number following 1 if I am to make sense of any claims involving it. And starting from this knowledge I can build up an understanding of what it is for a number to be the number 2.

In the same sort of way it might always be true that when an agent intentionally makes something happen, the agent's intending to make it happen causes it to happen, while this fact is a *consequence* of a proper account of action rather than being *part* of one. The causal theory of action is more than just a claim about what causes what in action. It is a claim about how to understand action; it is a

theory.]And it might be true that your beliefs and desires cause your body to move, and yet this fact might not be part of an understanding of what it is for you to act. What I have in mind is Nagel's idea, introduced towards the end of Chapter 3, in which mental states – in particular motivated desires – may be attributed in virtue of an agent being motivated to act in a certain way rather than being part of an account of what it is to be motivated to act.

Conclusion

The debate over the causal theory of action has been one of the most hotly contested issues in the philosophy of action over the past fifty years. The central question is whether action should be understood in terms of an agent's psychological states such as their beliefs and desires causing their bodies to move or further external results to happen. This issue can be broken down into two parts: do psychological states cause body movements and further intended results; and does this causal relation constitute what an action is? I have focused mainly on the first of these in this chapter and shall look a bit more at the second of these in Chapter 6. Concerning the first part of this question, Davidson was largely responsible for turning the tide of the debate in favour of causalism against anti-causalism. But while he certainly responded effectively to several quite weak arguments against causalism, there is a coherent anti-causalist position that remains available. This is the view that psychological states such as beliefs, desires and intentions and the characteristic results of action such as body movements cannot be identified independently of one another. This view rejects Davidson's materialist conception of psychological states as identical with brain states and it denies that the characteristic results of action can be described in purely physical non-psychological terms. If psychological states and action results cannot be identified independently of one another then it does not make sense to describe one as causing the other.

Deviant causal chains and causal processes

6

Deviant causal chains

Suppose we accept that the causal theory of action provides a necessary condition for intentional action. This means that if an agent acts intentionally then some state they are in or some aspect of their psychology causes the event of their behaving in a certain way or their body moving in a certain way or certain other results being achieved. It does not follow that this is a *sufficient* condition: that *if* the causal condition is met then the agent must be acting intentionally. Indeed it would follow from the possibility of deviant causal chains – a possibility I consider in this chapter – that it is *not* a sufficient condition. But for the causal theory of action to be part of a complete account of agency it had better be part of a set of conditions that are both necessary and jointly sufficient. So the causal theory has some work to do if it is supposed to do more than just reveal some conceptual commitments in our idea of action.

Chisholm (1966) describes a case where someone wants to kill his uncle to inherit a fortune, and having this desire makes him so agitated that he loses control of his car and kills a pedestrian, who turns out to be his uncle. The conditions of the causal theory seem to be satisfied. The nephew's wanting to kill his uncle causes his body to move in a certain way, resulting in the intended state being achieved. But of course this is not a case of intentional action; so something is missing from the causal theory.

It is very natural to reply that although the nephew did intend to achieve the general result of the uncle being killed, and this intention did cause that very result to occur, he did not intend to kill his

uncle in that precise way. He really intended to *shoot* his uncle, not run him over. So perhaps if we insist that the intended result is specified precisely enough it might be possible to avoid this sort of counter-example.

Now, while this proposal has got around the original counter-example, it seems that we can construct a new counter-example to defeat it. Suppose the nephew did in fact intend to kill his uncle by running him over, but that his intention to do so caused him to be so nervous that he accidentally swerved into the pedestrian who turned out to be his uncle. This time he intended to kill his uncle in the way he did; but still he did not run him over intentionally.

We might respond that he did not intend to run over his uncle just *when* he did run him over. But again we can adjust the counter-example. Let us suppose that he did intend to run him over just then. We may even suppose that he knew that this pedestrian was his uncle. But if all of this made him so nervous that he swerved the car in response to the nervousness, then his behaviour was still accidental.

Imagine a would-be murderer with a gun who, when faced with the moment when she has to pull the trigger, gets cold feet and cannot do it. The would-be victim is standing there taunting the would-be murderer, "You haven't got the guts to do it". And he is right. The would-be murderer's conscience has defeated her murderous intention. With the gun shaking in her hand, sweat pouring off her, and a voice in her head saying, "Do it, do it now!" she changes her mind and puts down the gun. "You're not worth the bullet," she says. But now imagine the very same would-be murderer with just one difference. Just before she would have put the gun down, her nervousness means that she loses control of her muscles, her trigger finger pulls in a spasm and the gun goes off. She would not have gone through with it, although she might not realize that herself in advance, but her intention to shoot the victim at that very moment does cause the victim to get shot at that very moment. Now she is not going to do very well in a court of law with that defence. And she might herself be quite unclear whether or not she committed the murder. But if the story were determinately as I have stated it, then the killing would have been accidental, not intentional, even if neither a jury nor even she herself could know that.

One further response might be to observe that after the accidental swerving or shooting it would be right to say that the nephew or

the would-be murderer just discussed did not intend *that*, where "that" refers to the particular act or achievement. They intended that *sort* of result, but not that particular result. That particular result was accidental. So if the action is specified *demonstratively* (i.e. using words like "this" and "that") rather than *descriptively* (in terms of its properties) it appears that in the case of deviant causal chains the intention and the result do not match up. And a causal theory that uses a demonstrative specification rather than a descriptive one would not suffer from deviant causal-chain counter-examples.

Such a causal theory might look like this:

> Some result is intentionally achieved if and only if the agent intends to achieve that particular result and this intention causes that result to be achieved.

We could then respond to the Chisholm-style counter-examples by saying that in those cases where the achievement of the result was accidental, the agent did not really intend to achieve that particular result.

Now the idea of a future-directed demonstrative is problematic. "That result" seems to refer to something not yet achieved when we say that the agent intends to achieve that result. And this would undermine the natural idea that a demonstrative expression such as "that result" must pick out something available to consciousness, and therefore *present*. But we can get around this by treating the intention in the causal theory as one that is present at the same time as the result is being achieved. In intentional action, it is the intention to achieve *this* that is causing this to be achieved.

The real problem with the proposal is that it does not properly answer the question of how to characterize intentional action. For the question of whether the nephew really intended *this* is exactly the same as the question of whether his action was intentional. It is just stated in a different way. We need an account of what it means to say that he intended this particular action, and this is what the causal theory was supposed to deliver. Also if we had such an account there would be no need to require that such an intention *caused* his behaviour, for the very fact that he intended that action entails that the action was intentional. It seems that for the causal theory to do any real work, the causally prior intention must pick out the result in a

descriptive way. But if it does then deviant causal chain counter-examples can be found.

Interestingly, such counter-examples can be produced against other types of causal theory too. A causal theory attempts to account for a causal idea just in terms of a certain kind of cause and a certain kind of effect. It has the following form:

A if and only if C causes E.

For example, you might try to produce an analysis of the idea of water dissolving some salt in terms of some aspect of the water or event taking place in the water causing the salt to dissolve. Here is a causal theory of water dissolving salt:

The water dissolves the salt if and only if the salt being immersed in the water causes the salt to dissolve.

But we could devise a counter-example by supposing that some electrostatic feature of the situation blocks the normal process of the water dissolving the salt, but that the salt being immersed in the water causes via some bizarre process some other solvent to be created that dissolves the salt. The causal condition of the analysis is satisfied, but the water did not dissolve the salt. Similarly it is not a sufficient condition of the wind breaking off a branch that the event of the wind blowing caused the branch to break off. The event of the wind blowing might have caused a bear to wake up, which, as a result of waking up, then jumped up and down on the branch, breaking it off.

In all these cases the right sort of cause is in place but it causes the effect in the wrong sort of way. The wrong sort of causal *process* results in the effect. So it seems that any causal account should include at least three elements: the cause, the effect and *how the effect is caused* – the process.

Can the appropriate causal route be specified?

Davidson expressed the problem for the causal theory of action by saying that the "point is that not just any causal connection between rationalizing attitudes and a wanted effect suffices to guarantee that producing the wanted effect was intentional. The causal chain must

follow the right sort of route". And Davidson went on to despair of spelling out "a way in which attitudes must cause actions if they are to rationalize the action" (1980: 79). But was Davidson right to despair? In examples of deviant causal chains there are various stages in the causal process that are somehow illicit and other stages that should be there but are not. The bear jumping up and down on the branch is not a proper stage in a process of the wind breaking the branch. Similarly, in Chisholm's example the nephew's nervousness is not a proper stage in the process of murdering uncles.

It is very tempting to try to fix a causal theory by specifying what intermediate stages there should and should not be in the causal chain. For example, we might require that the causal chain in a process of the wind breaking the branch should not pass through something other than the wind and the branch. Or we might require that it should pass through this, that and the other event. In the case of action we might require that the causal chain should only pass through events that the agent is aware of, or intends, or at least does not find surprising.

These causal theories are of the form:

A if and only if C_1 caused C_2 which caused C_3 …
which caused E

combined with some extra conditions about what is not allowed to be in the chain. It is still a theory where the causal process is characterized by spelling out causes and effect, just more of them. And other conditions need to be included too.

This sort of response to the problem of deviant causal chains looks very unpromising. The inclusion of a set of extra negative conditions is *ad hoc* and means that we no longer have a simple causal account of a simple causal notion. Moreover, these negative conditions invariably rule out things that should not be ruled out and include things that should be ruled out. In the case of the wind breaking the branch, the bear jumping up and down on the branch *might* have been a causal stage in a non-deviant breaking process. The bear jumping up and down on the branch might have been essential in weakening the branch to the point where it was possible for the wind to break it. But equally, it might not have been a causal stage in the process.

In the case of the causal theory of action, it would be wrong to require that nervousness cannot be part of the causal chain. Sometimes nervousness is a perfectly legitimate stage in the causal story of an action. Think of an actor saying that they need to get really nervous in order to play some part properly. Also it would be wrong to require that the stages in the causal chain were all intended, for in any normal case of intentional action there are many intermediate stages both psychological and physiological that the agent is not aware of, does not intend and indeed would be surprised to know happened. Trying to shore up a causal theory by describing the intermediate stages in the causal chain that must be present is also a fairly hopeless strategy. Again, it would rule out perfectly good examples of intentional action. But the most obvious objection is that it will always be possible to interpolate a deviant causal chain between any two of the specified stages. However close together the stages are it will always be possible to devise a situation in which some absurd and accidental causal process links them.

Two conceptions of a causal process

No such attempt to specify appropriate causal routes in intentional action has succeeded, and it is tempting to think that no such attempt ever will succeed. So Davidson's despair at being able to specify the right sort of route seems well motivated. But perhaps Davidson's implicit identification here of the notion of a *way of causing* or a process with that of a *route* or a causal chain is the mistake. Davidson may have been quite right to despair of spelling out the route that would characterize intentional action, but this does not mean that he was right to despair of spelling out the way in which actions must be caused by their reasons.

Davidson's identification of a process with a causal route is the way Bertrand Russell approached the issue. For Russell a process is identified with a causally connected structure of stages: a causal chain. Russell wrote: "Motion is the occupation by one entity of a continuous series of places at a continuous series of times" (1903: §442). This claim can be extended to processes generally. Then we would say that a process is a continuous series of states of affairs. A process is a series of process-stages; and a causal process is a causally connected series of process-stages.

But there is an alternative conception of processes, one we owe to Aristotle. Aristotle said, "Motion is the fulfilment of what exists potentially, in so far as it exists potentially" (*Physics*, 201a10–11). So, for Aristotle, a process is the realization of a potentiality for a certain structure of stages to occur. You have to characterize a structure of stages to specify the potentiality. But what is required for the process to be happening is not just that that structure of stages is in train, but that there is a *potentiality* for such a structure and that this potentiality is being realized.

What is a potentiality? This is a rather fraught philosophical issue with no clear agreement.[1] But a rough idea of what a potentiality might be is as follows. A potentiality is a real state of a system grounded in its underlying nature. When a system is in that state the characteristic results will follow when various operating conditions are met and nothing interferes. To say that salt has the potentiality to dissolve in water is to say that there are some underlying properties of the water–salt system given which the salt will dissolve when it is immersed in water, some other conditions of temperature, pressure and so on are met and nothing interferes.

To clarify the contrast between the two conceptions of a process, consider this process of salt dissolving in water. On the Russellian view this process consists of a causally connected continuous chain of stages from solid crystals of salt being immersed in the water to all the salt being dissolved in the water. On the Aristotelian view the process is identified with the realization of the potentiality of the salt to dissolve in water. In other words it is the realization of the various operational conditions of the water–salt dissolving system. The state of fulfilment of the potentiality of salt to dissolve is precisely the process of the salt dissolving in water. On this view a process is a state – a dynamic state – not a series of events.

On the Aristotelian view, as I am interpreting it, there are two sides to something having a potentiality. There is the structure of stages that characterizes what the potentiality is a potentiality for. And there is that underlying nature or set of conditions that grounds the potentiality. What crucially distinguishes this from the Russellian view is that it supposes that when you say that a causal process is going on you are not just describing a sequence of causally related events; you are making a claim about the existence of some underlying state – what *grounds* the potentiality for this sequence of events. When you

attribute a potentiality – for example, the potential to dissolve in water – you are making an assertion about what will happen in certain circumstances. But there must also be something that entitles you to make this sort of assertion. And this something is the underlying state and situation of the thing with the potentiality.

Suppose I have a magic genie who grants my every wish. I could wish that whenever this bit of salt was placed in pure gaseous oxygen it would dissolve. The genie would be on hand somehow to make this happen if the salt were placed in pure oxygen. Equally my bit of salt might for some reason not be soluble, but if I wish that it dissolves whenever it is placed in water, the genie will make sure that that is exactly what will happen. The fact that I am entitled to say of my bit of salt that it will dissolve if placed in water does not mean that the salt is soluble. Only if it is the nature of the salt–water itself along with its environmental situation that justifies the assertion can we attribute this potentiality to it.

C. B. Martin (1994) presents the example of an electrofink to make the point that there is neither a necessary nor a sufficient relation between something having a potentiality and the truth of some corresponding statement about a structure of stages, such as "If the salt is placed in water it will dissolve". His example concerns the *liveness* of a piece of wire: its potentiality to give an electric shock or more precisely the potentiality for an electric current to flow from the wire to a conductor if it is touched by a conductor. Suppose we have a live wire connected to an electrofink. An electrofink is an imaginary intelligent machine that can work out whether or not the wire is just about to be touched by a conductor, and switches off the current at exactly the moment the wire gets touched, and switches it on again afterwards. In other words the wire is live unless it is being touched by a conductor, at which point it is rendered not live by the electrofink. When the wire is not in contact with a conductor the conditional statement "If the wire is touched by a conductor then electric current flows from the wire to the conductor" is false, but the wire is still live. It is live because its underlying state grounds the potential for an electric current to flow if it is touched by a conductor, even though it is not true that an electric current will flow if it is touched by a conductor.

The electrofink can also be switched around so that the wire becomes live only when it is touched, but is not live at other times.

Here we would want to say when the wire is not being touched that the conditional statement above is true even though the wire is not live. It is not in an underlying state that grounds the potentiality for a current to flow if it is touched by a conductor even though it is true that a current will flow if it is touched by a conductor.

The example of the electrofink suggests that a causal process is more than just a Russellian structure of stages combined with the truth of some conditional statements linking them. Although a potentiality may be characterized by describing a set of conditional statements, these conditional statements are not supposed to be blankly true. They are only supposed to apply when the underlying conditions of the potentiality along with its further operating conditions are fully in place: that is, when the potentiality is being realized.

The characterization of the structure of stages that a potentiality is a potentiality for may be more or less complex depending on the process. The process of salt dissolving or a live wire conducting have very simple characteristic structures of stages. The crystalline salt in the water becomes ionized and distributed through the water. Electric current flows from the wire to a conductor if the wire is in contact with a conductor. But, for example, the process of a computer program operating will have a much more complicated characteristic structure of stages. If the number input here is x and the number input there is y then the number output there is $f(x, y)$, and so on. And if we think of action as a process with an underlying potentiality in this way then it will also be characterized in a complex conditional way. I shall consider how action potentialities should be characterized shortly. First, we must consider why this Aristotelian conception of a causal process is so very unpopular with philosophers of causation.

The empiricist attack on Aristotelian causation

In the Russellian approach, causation is constituted by two elements – the cause and the effect – and a single causal relation linking them. If we want to say that there must be something else joining the cause and the effect, all we can add is a third element, which is an effect of the first and a cause of the second. In other words the basic structure of two elements with a causal relation linking them can be

repeated in a chain. But no other *sort* of element need be posited. According to the Aristotelian approach, however, causation is constituted by three sorts of element. There are potentialities, causal inputs that feed into these potentialities and effects that result from the realization of these potentialities.

What seemed so obscure about this model to modern philosophers from Descartes onwards was the apparent unobservability of the element connecting causal input and effect. They thought that neither potentialities nor their realizations could be observed. All we can really observe are causes and effects. This scepticism was famously summed up in Molière's sarcastic treatment of Aristotelian doctors appealing to the dormitive virtue of opium to explain why it makes one sleep. All that the phrase "dormitive virtue" can mean is "power or potentiality to make one sleep", and what possible explanatory gain is made by appealing to that in explaining why opium makes people sleep?

Hume's attack on Aristotelian causation is one of the most powerful and influential.

> When we look about us towards external objects, and consider the operation of causes, we are unable, in a single instance, to discover any power or necessary connexion; and quality, which binds the effect and the cause, and renders the one an infallible consequence of the other. ... But were the power or energy of any cause discoverable by the mind, we could foresee the effect, even without experience; and might at first, pronounce with certainty concerning it, by the mere dint of thought and reasoning.
>
> (*Enquiry Concerning Human Understanding*, section VII)

Were you able to perceive powers you would perceive the necessity of the effect given the cause; this means that if you perceived the cause and its powers you would not even be able to imagine the effect *not* to follow; but however much you perceive of the world before the effect occurs you can always imagine the effect not to follow; so you cannot perceive powers in things.

Now the necessity of the effect given the cause in the Aristotelian model is a highly qualified necessity. The salt must dissolve *if* the process is working and not interfered with. This means that not only

must the power or potentiality be present, but its operating conditions whatever they are must hold and there must be nothing interfering. Suppose you perceived all the properties of the salt and water in complete detail and also knew that all the required conditions hold and nothing was interfering. Is it still possible to imagine the salt not dissolving?

It would be possible if all the properties of the salt–water system that you could perceive were properties that have no implications for the future. The empiricists assumed that you could never perceive an *if–then* state of affairs. All you could perceive were instantaneously present qualities: complete at a time. For empiricists the building blocks of experience could not themselves have an inferential structure. What we experience are categorically present features of the world. We can never experience that we are entitled to make an inference.

This is deniable.[2] In perceiving the blueness of a balloon I am perceiving its disposition to look blue to ordinary observers in ordinary circumstances. And this is the case even if it looks purple at the time because I am looking at it through rose-tinted spectacles. Even though it looks purple in the unusual conditions that prevail I can see that it is blue; I can see how it is disposed to look in ordinary circumstances. Perception is not always a matter of instantaneous recognition of qualities. You have to learn how to see things. Even simple colours cannot be recognized the first time you look. Generally you may need to interact with something for a while – exploring it – before you can perceive its properties. And in this process what you are exploring and discovering is the way it is in different circumstances; you are exploring and discovering its dispositional nature.

Perception of such conditional properties is not going to be infallible. Just because you think you have perceived the solubility of salt it does not follow that you have. But the idea that perceptual experience must be infallible is not compulsory. Given only what you think you have perceived it is always possible to imagine salt not dissolving in water however optimal the circumstances. This is because it is possible to imagine that you are mistaken in thinking you have perceived its solubility. But if you really have perceived it and the circumstances are right, then the salt must dissolve; nothing else is even imaginable on this assumption.

In any case the conclusion of Hume's argument is really too strong, for it does not undermine just Aristotelian causation but any sort of causation. According to Hume we are not entitled to assume that cause and effect are related in any other way than by constant conjunction. And constant conjunction is not itself causation.

An Aristotelian causal theory of action

If we can appeal to Aristotelian processes we can develop a different sort of causal theory of action, one that is not susceptible to deviant causal-chain counter-examples. The suggestion here is that we should not have an account of the form:

> An agent intentionally achieves E if and only if they intend to achieve E and their intending to achieve E causes the achievement of E.

Instead we should have an account of the form:

> An agent intentionally achieves E if and only if the achievement of E results from a process that is the realization of a potentiality which is described in terms of the sensitivity characteristic of intentional agency.

To characterize agency you do not just say that a certain sort of cause causes a certain sort of effect. You also have to say that the effect is caused in a certain sort of way. You have to describe the process of action in terms of what would have resulted from that process in alternative situations. You have to describe it in terms of the sensitivity of the process to different kinds of situations.

What is the sensitivity characteristic of intentional agency? One's first thought might be that the process of acting should be sensitive to what is intended; if X is intended then X should be achieved. But describing agency only in terms of achieving intended goals is to ignore the practical side of action. It is to ignore the possibility of acting intentionally while failing to achieve the intention. With a limited repertoire of basic acts at our disposal we do not *simply* achieve our intended goals when acting; we do what we should do

in order to achieve our intended goals. The sensitivity characteristic of agency is *teleological*.

My suggestion for how to account for the causal notion of action is the following:

> An agent intentionally achieves *E* if and only if the achievement of *E* results from a process that is the realization of the potentiality to produce what should be achieved in order for the agent's intended goals to be achieved.[3]

Sometimes doing what should be done in order to achieve a goal does not result in the achievement of the goal. What should be done in order to get some money might in the circumstances be to visit a cashpoint machine. But for one reason or another this may fail to result in actually getting the money. In such a case of acting with the goal of getting the money we say that the agent *tried* to get the money. Trying and failing is as much the realization of the potentiality to act intentionally as trying and succeeding.

Alien intermediaries

Harry Frankfurt defended this sort of approach, claiming that action must be regarded as a special sort of process – a sensitive guided process – and not a special sort of causal chain:

> [T]he state of affairs while the movements [of a person's body] are occurring is far more pertinent [than the causes from which they originated]. What is not merely pertinent but decisive, indeed, is to consider whether or not the movements as they occur are under the person's guidance. It is this that determines whether he is performing an action. Moreover, the question of whether or not movements occur under a person's guidance is not a matter of their antecedents. Events are caused to occur by preceding states of affairs, but an event cannot be guided through the course of its occurrence at a temporal distance.
>
> (1978: 158)

For Frankfurt, what distinguishes guided action is the causal process realizing some underlying potentiality or mechanism and not the

causal antecedents. Deviant causal chains are not a problem for this sort of account since action is not characterized in terms of a causal *chain* of any sort. There is no space in the process of a potentiality being realized in which a deviant causal chain can be interpolated. In Chisholm's example of the nervous nephew running down his uncle, the nephew's body movements and the resulting death of the uncle do not belong to a process that is the realization of the right sort of potentiality. They belong to a potentiality for nervous spasms or something like that. And such a potentiality does not have the sensitivity characteristic of intentional agency. This is because the nervous spasm mechanism does not characteristically result in what should be achieved in order for the agent's goals to be achieved.

One philosopher who thinks this is not good enough is Robert Audi. He has an approach to acting for a reason that builds on the notion of guided action. He says that "an action for a reason is one that is, in a special way, under the control of reason. It is a response to, not a mere effect of, a reason" (1993: 177). But Audi sees a problem with this as it stands in the possibility of alien intermediaries. His example concerns Tom, who intends to look at his watch to shorten a conversation. Unbeknown to Tom he has an alien called Ann living in his brain. She can manipulate his mind at will by manipulating his brain. Ann "likes to think she is making people do things that they would do anyway" (*ibid*.: 164). She presses her buttons and Tom, as a result, looks at his watch when and in the way he was intending to. He does not notice a thing.

Ann is an alien intermediary: a generator of deviant causal chains. She is like an electrofink of human brains. Audi thinks that when she is active there is a potentiality or mechanism present that works in just the right way characteristic of human agency – a process that turns intentions into actions – and that Tom's behaviour results from this process, but that Tom's behaviour still does not count as intentional action. But I think that Audi is not seeing the real force of his Aristotelian account, which concentrates on special kinds of causal processes rather than special kinds of causal chains. Alien intermediaries are already ruled out, since the process resulting in Tom looking at his watch under Ann's control cannot in fact be described in terms of the realization of a potentiality to produce what should be achieved for Tom's intentions to be achieved. It looks like it can since Ann is so respectful of Tom's intentions. But

the process really depends on what should be done given *Ann's* intentions, not Tom's.

To see this, consider what would result from the Tom–Ann process if Tom intended to kill Ann. As it happens, Ann makes sure that Tom does not know that she exists. But to assess the sensitivity of the process, we must consider what would result in this circumstance. Presumably the process working in this situation would not result in what should be done for Ann to be killed. Ann may be respectful of Tom's intentions, but there is a limit. This shows that the process is not really sensitive to the requirements of Tom's intentions, but to those of Ann's intentions, which happen for the most part to depend on and coincide with Tom's. Of course, Ann may install herself as a slave for Tom, devoting herself entirely to making Tom do what he was going to do anyway. Suppose that she has no reasons for action that ever diverge or could diverge from Tom's. However boring, horrible or self-destructive it is to make Tom do what he intends to do, she will stick it out forever. In this case I think it may be right to say that Tom is indeed acting intentionally and Ann is just a redundant prosthetic device: a pointless extra loop. Her own reasons have lost any independent causal role. In this case the process that results in Tom's behaviour is truly sensitive to what should be done to achieve his intentions.

Conclusion

I think it is clear that the possibility of deviant causal chains does undermine any causal theory of action (or of anything else for that matter) that aims to provide sufficient as well as necessary conditions and that accounts for action in terms of a special kind of cause, a special kind of effect, and a *generic* causal relation linking them. I have suggested that the solution is to account for action in terms of a special kind of cause, a special kind of effect and a *special* kind of causal relation.

I have described the thing that links cause and effect as a causal *process*. It can either be understood in Russellian terms as itself consisting of a series of cause and effect links, in which case the problem of deviant causal chains will re-emerge, or it can be understood in Aristotelian terms as the realization of a special kind of potentiality or mechanism. A potentiality has two sides to it: an

underlying state of the system that *grounds* the potentiality, and the structure of stages that *characterizes* the potentiality. The characteristic structure of stages follows if the grounds of the potentiality are present, are activated by whatever further operational conditions might be required and are not interfered with.

I have suggested that the structure of stages that characterizes a process of acting might be described in terms of some sort of responsiveness to reasons. In particular, what results from such a process is whatever *should* be achieved in order for the agent's intentions or goals to be achieved. This is one way of spelling out the notion of *sensitivity to reason* that has been in the background of much of the discussion since Chapter 2.

Understanding causal processes in Aristotelian terms and understanding causal notions, like action, in terms of such causal processes completely avoids the problem of deviant causal chains. This is because such processes are not taken to be causal chains of any sort. In the deviant causal-chain examples a different kind of process is always operating: not one characterized in the way appropriate for intentional action.

7 Acting with an intention

Introduction

It seems very natural to suppose that acting intentionally is acting with an intention. Since having an intention is being in a certain state of mind, it follows that acting intentionally essentially involves being in a certain state of mind. This may appear to support an inward-looking approach to agency: an approach that attempts to find the essence of agency in some aspect of the agent's state of mind. But this defence of an inward-looking approach depends on an inward-looking approach to intentions. Its correctness depends on intentions being mental entities that can be understood independently of their role in intentional action. For example, if intentions have some intrinsic nature knowable by introspection to the agent, then understanding this intrinsic nature of intentions will provide an inward-looking understanding of agency. But if intentions can only be understood in terms of their role in intentional action, then explaining intentional action in terms of intentions is to go around in a circle, and this particular inward-looking approach would be undermined. An outward-looking approach to action would go with an outward-looking approach to intentions.

It is the task of both this chapter and Chapter 8 to investigate whether we can derive a theory of intentions from a theory of intentional action. Should we try to understand what it is to have an intention in terms of what it is to act intentionally or should we try to understand what it is to have an intention independently of what it is to act intentionally? In this chapter I focus specifically on intentions that one has while acting. In Chapter 8 I consider

whether different problems arise when we take into account *prior* intentions.

In his "Actions, Reasons and Causes", Davidson argues that we *can* derive an account of intentions from an account of intentional action. He presents the causal theory of intentional action that I have discussed in previous chapters. Here is a paraphrase: an agent's achieving E counts as an event of their *intentionally* achieving E if and only if the agent has a pro-attitude (e.g. desire) to achieving E and believes that what they are doing is achieving E, and that this pro-attitude and belief together cause this achievement of E.[1] We are assuming that if an agent is intentionally achieving E then they are acting with the intention to achieve E. So we may use this causal theory as an account of what it is to act with an intention as follows: an agent's achieving E counts as an event of their achieving E with the intention to achieve E if and only if the agent has a pro-attitude to achieving E and believes that what they are doing is achieving E, and this pro-attitude and belief together cause this achievement of E.

Davidson wrote: "The expression 'the intention with which James went to church' has the outward form of a description, but in fact it is syncategorematic and cannot be taken to refer to an entity, state, disposition, or event" (1980: 8). What he meant by *syncategorematic* was that the word "intention" is not supposed to stand alone to refer to something, but only has meaning in a larger phrase such as "acting with an intention". That an agent who acts intentionally is not in a state of having some intention is an unnecessarily strong claim, however. Davidson might have said something a bit weaker (and more plausible) instead, namely that we cannot understand what it is to have an intention except by understanding what it is to act with an intention.

If Davidson was right and we can work out a theory of what it is to act with an intention in terms of what it is to act intentionally, then the theory of action must not itself appeal to intentions. If it did then we could not account for intentions in terms of it without circularity. Davidson's own account appeals to beliefs and pro-attitudes or desires; so it does not involve that circularity.

The Aristotelian way of formulating a causal account of intentional action that I proposed in Chapter 6 does refer to intentions (or at least *intended goals*), but it may be possible to eliminate such

reference and use it too as the basis of an account of acting with an intention. The account as stated there was as follows:

> An agent intentionally achieves E if and only if the achievement of E results from a process that is the realization of the potentiality to produce what should be achieved in order for the agent's intended goals to be achieved.

The reference to intended goals may be eliminated as follows:

> An agent intentionally achieves E if and only if the achievement of E results from a process that is the realization of the potentiality to produce what should be achieved in order for E to be achieved.

According to this theory, if an agent intentionally achieves E (and so E is their intended goal) then the achievement of E results from the realization of a potentiality to produce whatever should be achieved for E to be achieved. In other words the agent's behaviour must adapt to what they should do in order to achieve E. Now the further move that makes this a theory of intentions is to say that this does not merely *follow* from the agent acting with E as their intention; it is part of *what it is* for the agent to act with E as their intention. So we get the theory that what it is (or part of what it is) to act with an intention E is to act in a way that is adaptable to what should be done in order to achieve E. Your intended goals are the results that your behaviour adapts to.

In this chapter and Chapter 8 I shall try out this approach to intentions in a series of interesting philosophical issues concerning intentions. I think that it works quite well by comparison with rival accounts in dealing with these various issues.

Relationship between acting intentionally and having intentions

But is it even true that acting intentionally requires having an intention? Or, to be more precise, is it true that intentionally φ-*ing* requires having an intention to φ? If it is not, then this would be a setback for any attempt, like Davidson's, to provide a theory of intention in terms of an account of intentional action.

Now it might plausibly be denied that intentionally φ-*ing* requires you to have a *prior* intention to φ. Think about saying to a child, "Would you mind putting those toys away in the big box by the window", and consider the intentional action of saying the word "big" in the course of uttering the whole sentence. You said the word "big" intentionally and you said it with the intention of saying it. But before you actually uttered it you had no such intention. Something relevant was going on in your brain no doubt, but not enough to say that you were really intending to say "big". Perhaps up until you started to form the consonant "b" you were intending to say: "Would you mind putting your toys away in the box by the window." But as you were starting the "b" you decided to say "big" to make it clear which box you had in mind.

If this is right, then the intentional action of saying the word "big" does not require a *prior* intention to say it. What is required is that you say it *with* the intention of saying it. So while you say it you have a current intention to say it. But is it possible to deny that intentionally φ-*ing* requires having a current intention to φ too? Might you do something intentionally without intending even at the time to do it?

One approach is to consider the fact that the very same action may be described in quite different ways, some of which reveal the intention with which the action was done and some of which do not. A standard plot piece in many derivative Hollywood comic thrillers is for a bank robber to succeed in a daring robbery only to find that the money they have stolen belongs to a mafia boss whom they really do not want to upset. Here is a conversation between the (philosophically educated) bank robber and Mafia boss.

"I'm sorry boss, I didn't intend to steal your money."

"What do you mean? Did my money just drop into the back of your truck while you were looking the other way?"

"We intended to steal the money of course, but not knowing it was yours, we didn't intend to steal *your* money. The robbery itself was intentional but we did not intentionally steal money from you boss."

"So let's see if I've got this right you low-life scumbag. You stole the money from the bank intentionally. But stealing the money from the bank just was stealing my money. So by

Leibniz's law of identity your action of stealing my money was an intentional action. But you didn't intend to steal my money? Eat lead, loser!"

What has gone wrong here is the Mafia boss's use of Leibniz's law of identity. His argument is as follows:

Your robbing the bank was the very same action as your taking my money.

If $a = b$ and a has some property f then b has that property f (by Leibniz's Law).

Your robbing the bank was intentional.

So your taking my money was intentional.

The mistake is the assumption that *being intentional* is a property of an action rather than being a property of the way the action is described. You did not intentionally take the Mafia boss's money even though you did intentionally rob the bank, despite these being one and the same action. So this is not a clear case of someone intentionally φ-*ing* without intending to φ.

A better attempt at a counter-example is provided by Michael Bratman's (1984) example of the ambidextrous video-game player. Imagine a simple video game in which you manipulate a joystick with one hand to guide a missile into a target. Suppose someone can play this game with either hand and now tries to play two such games using both hands simultaneously. He intends to hit the left target and he intends to hit the right target, and if he is successful in either or both cases he will intentionally hit either or both targets. Now suppose that the two video games are linked up so that once he hits one target the other game is over too. We can also assume that it is impossible to hit both targets simultaneously. This means that he cannot hit both targets any more. And let us assume that he knows about this link-up. Now when he plays, his goal is just to hit one of the targets. His strategy for achieving this goal is to do what he was doing before, that is, to try with each hand simultaneously to hit its target.

Suppose he succeeds in hitting the left target. It seems correct (at least at first) to say that he intentionally hit the left target. After all he was trying to hit it and this attempt guided his action in the normal

way, with the result that due to his skill in playing the game he succeeded in hitting the left target. But did he *intend* to hit the left target? The difficulty with this is that if it is right to say he intended to hit the left target it must also be right to say that he intended to hit the right target. His attitude to both was the same. But knowing that it is impossible to hit both targets, he cannot intend to hit both targets. And if he cannot intend to hit both targets he cannot both intend to hit the left target and intend to hit the right target. This is because the intentions you have must be worked into a consistent plan of action.

Intentions are unlike desires in this respect. You can simultaneously desire two things that you know are incompatible. But when you form intentions you are embarking on a course of action, and there is a much stronger requirement of consistency. If you know that your goals are incompatible you are rationally required to adjust your goals until they fit together into a coherent (even if sketchy) plan. So if the game player cannot be intending to hit the left target and intending to hit the right target it seems he cannot be intending to hit the left target, since there is no difference in his attitudes to the two. Rather than intending to hit the left target (or the right target) his intention must be merely to hit one of the targets. So it seems that he intentionally hits the left target while not intending to hit the left target.

Now I think Bratman is right to say that the video-game player does not intend to hit the left target in this case. If he did intend to hit the left target he would not be going after the right target at the same time, since hitting the right target would stop him from hitting the left. But I think that by the same token he cannot have been *trying* to hit the left target either (or the right one for that matter). So in this respect I think Bratman must be wrong. If he were really trying to hit it he would not have been going for the right target simultaneously. When he succeeded in hitting the left target there was no residual sense of failure in not hitting the right target. That is because he was not trying to hit the right target (or the left for that matter).

What he was trying to do was to hit one of the targets. And his method was not to do this by trying to hit both. His method was to try to hit the left target unless the right one got hit first and to try to hit the right target unless the left one got hit first. This amounts to doing the same as you would if you pretended that the two games

were not linked up and you were trying to hit both targets. But of course this does not amount to actually trying to hit both targets or even either target individually. Pretend there is a box of matches in front of you and try to pick it up. Did you actually try to pick up a box of matches?

So I think that Bratman's example fails since it is wrong to describe the video-game player who hits the left target as trying to hit the left target. So it is wrong to describe him as *succeeding* in hitting the left target; he succeeds in hitting *one of* the targets. And this is what he does intentionally. He intentionally hits one of the targets but does not intentionally hit the left target. As with the Mafia boss case, hitting the left target is the very same action as his hitting one of the targets. But it does not follow that it is intentional under that description. What he intends to do and what he does intentionally match up after all. He intends to hit one of the targets, and that is what he achieves intentionally. The video-game player does not adapt his behaviour to what he should do in order to hit the left target. If his behaviour were adaptive to that goal he would stop playing the right-hand game. His behaviour is adaptive to the goal of hitting *one* of the targets, and so, according to the Aristotelian version of the causal account of action, this goal is what he intentionally achieves.

It is important when considering this example to take seriously Bratman's specification of the game. It is not a game where he is repeatedly pressing a "fire" button sending a series of missiles at the target. If it were, then every time he pressed the fire button he would be trying to hit that target and at the same time intending to hit that target. There is no irrationality in intending to hit the right target and *then* intending to hit the left target and *then* intending to hit the right target, and so on. In such a scenario, when he hits the left target, we can say that he tried to hit it, he intentionally hit it and he intended to hit it. In the game as Bratman describes it there is one continuous action of guiding his missiles at the targets, not a series of discrete actions: separate firings. Bratman describes this single continuous action as guided by the single intention to hit one of the targets. But he thinks it is somehow constituted by two separate tryings – one to hit the left target and one to hit the right target – where neither of these tryings is associated with a specific intention, since there is no intention to hit the left target and no intention to hit the right target.

But I do not think he has convincingly shown that in the case where there is no intention to hit the left target it really makes sense to say that the video-game player tried to hit the left target.

Doctrine of double effect

Flying over enemy territory, the bomber pilot has the strategic bridge in his sights. His overriding goal is to contribute to ending this war and stopping the slaughter as quickly as possible, and he understands that destroying the bridge is his best means of doing that. As he sees the bridge more clearly he notices that there are hundreds of civilians on the bridge trying to escape from the killing fields. The bomber pilot has to act straightaway or not at all; the enemy fighters are on his tail. He knows it is horrible to kill a few hundred civilians; but he is convinced that in the end this act will bring a swift end to the war and result in fewer people being killed. He drops the bomb on the bridge, intending to destroy the bridge and knowing with a fair degree of certainty that this act will also kill hundreds of civilians.

Another war; another bomber pilot; flying over enemy territory he has the group of fleeing civilians in his sights. His overriding goal is to contribute to ending this war and stopping the slaughter as quickly as possible, and he understands that killing all these civilians in one go will have such a devastating impact on morale that the enemy leaders will be forced to sue for peace as quickly as possible. So he believes that killing the civilians is his best means to ending the war and minimizing the overall slaughter. As he sees the group of civilians more clearly he notices that they are on a bridge. He has no desire to destroy a perfectly good bridge, but he has to act straightaway; the enemy fighters are on his tail. He knows it is horrible to kill a few hundred civilians; but he is convinced that in the end this act will bring a swift end to the war and result in fewer people being killed. He drops the bomb on the bridge, intending to kill the civilians and knowing with a fair degree of certainty that this act will succeed in killing them.

The first pilot is a tactical bomber the second is a terror bomber. They both have the same good intention of stopping the war as quickly as possible. One of them (the terror bomber) also intends to kill hundreds of civilians, whereas the other (the tactical bomber) does not intend to kill hundreds of civilians, but knows that doing

what he does intend to do – namely blowing up the bridge – will kill hundreds of civilians.[2] The ethical question is whether the terror bomber is somehow more guilty than the tactical bomber in virtue of having the intention to kill civilians. According to the principle in ethics known as the doctrine of double effect, which for various interesting reasons is particularly associated with Catholic ethics, there is a significant ethical distinction between the terror bomber and the tactical bomber. It is always wrong to kill innocent people with the intention of killing them, but it is not always wrong to kill innocent people if you are acting with some other intention, even if you know that acting with this other intention will certainly result in your killing innocent people. Many people cannot see the moral force of this distinction. Perhaps it is just a trick to make room for the possibility of morally killing innocent people while desperately holding on to the exceptionless moral principle: never intend to kill innocent people. The doctrine of double effect sounds like double talk designed to obfuscate the true nature of war; namely, that it always involves large-scale murder.

Another example is the practice that doctors may adopt with terminally ill patients, when everyone agrees that there is nothing to be gained by the struggle for life continuing, of giving them enough morphine to eliminate their pain knowing that they are now so weak that the dose will certainly kill them. The doctor can claim that their only goal in this case is to alleviate the pain of the patient. The important thing is to keep the patient relatively pain-free in their last days, and it does not really matter if the painkiller itself shortens their life by a few days. The doctor in this case can avoid the thorny issue of euthanasia. They are not intending to kill the patient in order to alleviate their suffering; they are intending to alleviate the patient's suffering and are thereby killing the patient. Their knowledge of what will happen goes beyond the mere elimination of pain to the consequent death of the patient, but their intention need not go beyond the mere elimination of the pain.

Another doctor doing exactly the same thing might have done it with the intention of killing the patient. They might have used the morphine not as a painkiller, but as a poison. Their intention would be to kill the patient in order to alleviate their suffering: put them out of their misery, as it were. The first doctor, however, was just intending to alleviate the suffering. It might be practically

impossible in this sort of case to distinguish the doctors' motives. Perhaps, however, the hospital has run out of painkillers and all the doctor can give the patient is a painless poison that has no painkilling properties apart from the indirect painkilling property of killing the patient. The second doctor who intends to kill the patient would prescribe this poison, and the first doctor would not.

According to the doctrine of double effect the second doctor acts wrongly in prescribing the poison, because by giving it they are intending to alleviate the suffering *by killing the patient*. In a situation where euthanasia is outlawed, this doctor would be guilty. So in this case too it might look as if the real significance of the doctrine of double effect is public relations. You can put a better spin on the action by describing the death as an unfortunate collateral consequence, rather than as the goal of the action. Perhaps there is no real moral difference between the behaviour of the two doctors, and indeed the second doctor is morally braver. But in any case the question for the philosophy of action is not the ethical one, but the prior question of whether there is any difference with regard to the way the two actions must be described. Is there any difference with regard to intentions and intentionality, and if so what is it based on?

All the people in these examples are killing people. Even if you kill someone accidentally you are still killing them. But we would not even describe the tactical bomber or the morphine-prescribing doctor as *accidentally* killing people. It is no accident that the civilians die when a bomb is knowingly dropped on them; it is no accident that the patient dies as a result of a morphine dose that the doctor gives them deliberately, knowing full well it will kill them. Does it follow that the tactical bomber and the morphine-prescribing doctor are *intentionally* killing people? Certainly many people would say that they are intentionally killing people; if it is not accidental it must be intentional.[3] But I do not think our intuitions as to what to say here are very secure. The tactical bomber is killing civilians and he is acting intentionally when he kills the civilians, knowing that the civilians will be killed by what he does. But we are not forced by this into saying that he is intentionally killing the civilians. We might say that he is intentionally dropping a bomb on the bridge, and that this act is an act of killing hundreds of civilians and he knows it, but deny that what is intentional is the civilians being killed as opposed to the bridge being destroyed.

The reason we might deny this is that the tactical bomber does not intend to kill the civilians. It is no part of his plan that they should die, even if it is a known consequence of carrying out his plan in the circumstances. He is not aiming for that result. On the other hand the terror bomber is aiming for that result. It is part of his plan that the civilians should be killed. That is his intention. Similarly the morphine-prescribing doctor can claim that her intention was only that the patient should be free of pain. She was not aiming for the patient's death, although she knew that such a result was bound to follow. On the other hand the poison-prescribing doctor cannot claim such a thing. Her intention may also have been that the patient be free of pain, but since her means to achieving this result was to kill the patient she cannot escape the accusation that she intended to kill the patient.

What is this difference in intentions based on? Is it a difference in their hearts: a difference in what they fervently wished for? Certainly not. The tactical bomber might have been a much nastier character than the terror bomber. Perhaps he could not care less about the killing of all these innocent people, whereas the terror bomber might have hated it with all his heart. If there were only another way to avoid the continuing slaughter he would have gladly taken that other way. Nor is the difference based on what the different people believed. One might try to argue that giving poison to your patient is a much surer way of killing them, whereas giving them morphine might not kill them. In this way one might try to argue that the poison-prescribing doctor knows she is killing her patient whereas the morphine-prescribing doctor does not. But it might go the other way around too. Perhaps the poison is a very unreliable killer, whereas the doctor is absolutely certain that the morphine will kill her patient. It is still the case the poison-prescribing doctor intends to kill the patient and the other one does not.

The real difference is a difference in what they are *aiming* at. It is a difference in what goal their behaviour is directed to. And this difference may just be a difference in how they would *adapt* their behaviour in different circumstances. If the civilians had not been on the bridge but a quarter of a mile down the road, the terror bomber would still have bombed *them*, whereas the tactical bomber would not have done, but would still have bombed *the bridge*. This difference is explicable in terms of the Aristotelian version of the causal

theory of action. According to that theory the bomber intentionally achieves the killing of the civilians if and only if that achievement results from a process that is the realization of the potentiality to produce what should be achieved in order for the civilians to be killed. So he intentionally kills the civilians if and only if the process that resulted in their being killed is sensitive to the requirements of that goal: if and only if his behavioural process is adaptable to what is required to achieve that goal.

The same applies to the two doctors. If there is plenty of morphine in the hospital, both doctors will prescribe morphine, and it will be very difficult to tell them apart. But if there is only a painless non-painkilling poison, then the first doctor will not prescribe it and the second will. The potentiality realized in the behaviour of the second doctor is a potentiality that when realized characteristically results in the doctor doing what she should do in order for the death of the patient to be achieved.

If this is what the difference in intentions amounts to, it is clear why it is such a feeble mitigation ethically to say that you did not really intend the killing. The difference is only a difference in what you would have done in different circumstances. But what we care about is how things went in the actual circumstances – what you wanted, what you knew and what you did. What you would have done is of secondary concern.

Perhaps the distinction is useful legally even if it is not very useful ethically. If terror bombing is outlawed as a war crime and tactical bombing is not, it will not make any difference to the civilians on the tactically significant bridge; but it would stop the protagonist who is trying to avoid war crimes from descending into genocide. Equally, the restriction on doctors' behaviour that they should not intend to kill their patients might be a rather flimsy one in many cases, but it might be one that everyone concerned is happy to have in place. The system works quite well with that restriction in place, whereas if you allow doctors to prescribe non-painkilling poisons, problems might arise.

In states where it is illegal to kill a patient while intending to do so, but not illegal to kill them as a known consequence of intentionally alleviating their pain with morphine, it would be very natural for doctors who agree with their patient's desire to die to develop quite a complicated intention as follows. They might intend to kill

the patient so long as this can be done in a way that may also be interpreted as an attempt merely to eliminate the patient's pain and at the same time intend simply to eliminate the pain if that is not possible. This seems like a different intention from that of the doctor who only intends to eliminate the pain whether or not this results in the patient's death. But it is very difficult to see how the behaviour of these two doctors would ever diverge. Perhaps at this point any real distinction between the doctors has disappeared altogether.

I think we can summarize a few claims about intentions that this discussion of the doctrine of double effect has illustrated. First, having an intention is not a matter of having any knowledge or belief in the chances of success. The terror bomber and the tactical bomber may have the same beliefs and the same state of knowledge concerning the probable effects of their action on the death of the civilians. Secondly, having an intention is not a matter of having a particular desire or preference for the outcome. Both bombers have the same goal: to end the war as soon as possible with minimum loss of life. The difference between them stems from a difference in belief as to the most effective way of achieving that goal. The terror bomber believes that killing a crowd of civilians is the best way; the tactical bomber believes that destroying the bridge is the best way.

In one sense neither of them wants the civilians to be killed. However, in another sense the terror bomber does want the civilians to be killed, since that is his goal. But this desire derives from his intention, not the other way around. The emotional force behind the desire comes entirely from his desire to end the war, a desire that is shared with the tactical bomber. So the terror bomber's intention to kill the civilians cannot be accounted for in terms of some extra independent element of desire.

The only way to account for the difference between the two bombers – a difference marked by their different intentions – is in terms of the different adaptability of their ways of behaving. The terror bomber's behaviour adapts to what he should do in order to kill the civilians, and the tactical bomber's does not. This is some support for the approach to intentions that appeals to the Aristotelian version of the causal theory of action.

Shared intentions

Some more support can be provided by considering the phenomenon of different people sharing an intention to act together in a certain way. I want to suggest in this section that an inward-looking approach gives a less satisfactory account of this phenomenon than an outward-looking approach based on the Aristotelian version of the causal theory of action. Given an inward-looking approach to intentions this idea of sharing an intention cannot be treated literally. If an intention is an independently identifiable entity in the mind of an individual then it cannot be in two minds at once, and so not literally shared.

The phenomenon of shared intention is ubiquitous. While it might be convenient from an inward-looking perspective to deny its existence altogether, this is not really an option. When four people carry a piano upstairs, they have a common goal. They intend to act cooperatively to get the piano upstairs. A group of football players act together to score a goal; their shared intention is to score a goal, and they cooperate to achieve that intention. Even the players on opposing teams share the intention to play a game of football. When two people dance together, shake hands, kiss, or move aside from one another in passing they are acting cooperatively with common goals.

One of the most interesting examples of joint activity guided by a shared intention is language. The communicative function of language depends not just on shared understanding but on shared intentions. When one person says to another, "Please pass the salt", and the other one engages with this utterance and understands it, they share the intention that this request is passed from the first person to the second person. They each intend to cooperate in an achievement of communication. The same can be said for assertions such as, "I'm not going to the party tonight". Although the speaker and the hearer will have all sorts of different intentions concerning this utterance, there will be the shared intention that some information is conveyed.

Now it is a moot point whether communication must depend on the hearer sharing an intention with the speaker, since the hearer's role appears to be more passive than this. Will they not understand the communication whether or not they have any intention to do so? But at any rate communication based on shared goals is the norm, and the point is much more obvious when we consider extended

conversations rather than just single utterances. When you have a chat with someone you share the intention to cooperate in this activity.

Despite the phenomenon of shared intention being so ubiquitous and so interesting, philosophers of action very often ignore it altogether. And those who do deal with it often pursue a reductive line, according to which shared intention is understood in terms of individual intentions that interrelate in certain ways. They treat shared intentions as not being literally shared, but as being separate but closely related states of mind in separate individuals. Bratman is a good example. He argues that:

> a shared intention is not an attitude in the mind of some superagent consisting literally of some fusion of the two agents. There is no single mind which is the fusion of your mind and mine. ... My conjecture is that we should, instead, understand shared intention, in the basic case, as a state of affairs consisting primarily of appropriate attitudes of each individual participant and their interrelations. (1993: 98–9)

Bratman's general approach to intentions is to question Davidson's claim that we can understand what it is for someone to act with an intention in terms of what it is for someone to act intentionally. For Bratman intentions are mental states identifiable independently of intentional action. Since we cannot independently identify a literally shared intention in two or more people's minds, shared intentions should be understood in terms of individual intentions. His proposed account is as follows:

> We intend to J if and only if
> 1. (a) I intend that we J and (b) you intend that we J
> 2. I intend that we J in accordance with and because of 1a, 1b, and meshing subplans of 1a and 1b; you intend that we J in accordance with and because of 1a, 1b, and meshing subplans of 1a and 1b.
> 3. 1 and 2 are common knowledge between us. (1993: 106)

This analyses the idea of our intending to move a piano upstairs together in terms of the idea of each of us individually intending that

we move the piano upstairs together, and certain other conditions being satisfied. Not only is the account worryingly complicated, it appeals to this very unnatural idea that *I intend that we J*. It is natural to describe an individual as intending to do something, and it is natural to describe a group of individuals as intending to do something together, but it is very unnatural to describe an individual as intending that the group do something together.

"I'm going to move the piano upstairs" expresses my intention to move the piano upstairs. "We're going to move the piano upstairs" expresses our intention to move the piano upstairs. But what could possibly express *my* intention that *we* move the piano upstairs? Perhaps it would be "I'm going to make sure that we move the piano upstairs". But this expresses an intention to do something myself – an act of making sure – which is different from the intention to do something together – an act of moving the piano.

I think there is something unsatisfactory about reducing the idea of *our* having an intention to do something together to that of each of us having an individual intention that we do something together (along with other conditions being satisfied). An outward-looking approach like the Aristotelian version of the causal theory of action might avoid this unnatural reduction. According to such an approach it may be possible to make literal sense of the idea of a shared intention.

The idea of a literally shared intention is absurd if an intention is itself an entity existing in a mind. For then, as Bratman argues, a shared intention would have to exist in a super-mind: one that different people partake in. But when we talk about someone having in their mind an intention to move a piano what we mean is just that they intend to move a piano: they are in the state of intending to move a piano. Our language allows us to move from saying "I intend to move a piano" to "I have an intention to move a piano", but this does not mean that we can infer that there is some identifiable entity – an intention – quite literally belonging to me and existing somewhere in my inner world.

The English language (among others) allows us to make this sort of move all over the place. If a stone weighs one kilogram we can say that the stone *has* a weight of one kilogram. But we must not treat its weight as some independent entity possessed by the stone, distinct from another stone's weight of one kilogram, and existing in some

space of stone properties. Anything we say about weights must derive from our talk of things weighing certain amounts. Likewise if I am responsible for looking after a child I have a responsibility to look after her. But it would be a mistake to think of this responsibility as a thing with an independent life of its own existing in some realm of obligations. Anything we say about responsibilities must derive from our talk of people being responsible for certain things. And in exactly the same way, anything we say about intentions must derive from our talk of people intending to do certain things. Once we are clear about this it seems much less problematic to talk of four people literally sharing an intention to move a piano, for what this must mean is that there is a single state of intending to move a piano, and all four people are together in this state. It is not just a state of a person, but a state of a quartet of people.

When a couple is married there is a single state that both people are in together; they share that state. When a hundred dots are arranged symmetrically on either side of a line, there is a state of symmetry that they collectively are in; they share that symmetry. And when two people are jointly responsible for looking after a child there is a single state of responsibility that they are in to-gether; they literally share that responsibility. If the state of intend-ing to do something were a state of your mind quite literally, then it could not be the sort of state that two or more people were in together, unless they shared a mind. But the state of intending to do something is in the first instance a state of a *person*: a state the person is in mentally. And, given this, two or more people could be in it together.

The Aristotelian account that I have been working with in this chapter makes room for this possibility. The account goes:

> An agent intentionally achieves E if and only if the achievement of E results from a process that is the realization of the potenti-ality to produce what should be achieved in order for E to be achieved.

Assuming that intentionally achieving E can be identified with achieving E with the intention to achieve E, as I argued earlier in the chapter, then we have an account that boils down to saying that an agent achieves E with the intention to achieve E if and only if the

achievement of E belongs to a behaviour process that is adaptable to what should be done in order for E to be achieved. This can be extended to shared intentions as follows:

> A group of agents achieve E with the shared intention of achieving E if and only if the achievement of E belongs to a cooperative behavioural process that is adaptable to what should be done in order for E to be achieved.

This account does not invoke some super-mind that the individuals in the group share. But it does invoke the idea of a super-process of behaving that the different individuals partake of. This may be an easier idea to accept. The process is distributed across the activity of several people. But all this activity is adaptable to a single goal. And to the extent that that adaptability requires planning, coordination, determination and re-determination of means, all these aspects of planning must be understood collectively. This is what it means to *work together*.

An individual intention is a goal to which an individual's behaviour adapts. A shared intention is a goal to which a group of people's behaviour collectively adapts. What it is for the behaviour of a group to adapt to a goal is a fascinating question. A notion of cooperative means–ends rationality would need to be articulated in order to determine what should be done in order for a shared goal to be achieved. This is precisely the task of what we might call the philosophy of collective action.

Conclusion

I have been contrasting two approaches to intentions in this chapter. One approach, which Davidson championed in "Actions, Reasons and Causes", is to explain the idea of having an intention by providing an account of what it is to act with an intention. For Davidson what it is to act with an intention is for one's achievements (in particular body movements) to be caused by a primary reason consisting of a belief and a desire (or other pro-attitude). In the light of the difficulties with such a causal theory discussed in previous chapters, I have been considering instead an Aristotelian version of a causal theory of action as a way of explaining the idea of acting

with an intention. According to this version, what it is to act with an intention to achieve G is for one's behaviour to adapt to what should be done for G to be achieved.

The other approach, for which Bratman is a champion, treats intentions as states of mind that are understandable and identifiable independently of their role in intentional action. Bratman argues that, although intentions have a key role in intentional action – in particular in enabling plans to be formed – they are not logically bound up in intentional action. According to Bratman it is logically possible to achieve some goal intentionally without intending to achieve it.

I argued that Bratman's example of the video-game player does not show this conclusively. In considering the doctrine of double effect Bratman thinks it would be right to describe the tactical bomber as intentionally killing the civilians even though he did not intend to. Again I do not think we have to accept this. Indeed, the example of the terror and tactical bombers seems to provide some intuitive support for the idea that what is required for both intentional action and for acting with an intention is the realization of a potential to adapt one's behaviour to what one should do in order to achieve some result.

Finally, the possibility of a group of people quite literally sharing an intention casts doubt on the second approach. Bratman has to construe what we think of as shared intention as not literally involving shared intention but as involving interrelating individual intentions. The Aristotelian approach on the other hand can make room for a group of people literally sharing intentions, since this amounts to the activity of that group of people being adaptable to what should be done for a certain result to be achieved.

Davidson's later theory of intending

Davidson changed his mind about intentions between the time of his earlier article, "Actions, Reasons and Causes" and the slightly later one, "Intending" (1980: essay 5). In his earlier article he was keen to avoid what I have described as an inward-looking approach, and thought that the way to do this was to treat acting with an intention as the primary notion. His unstated presumption was that *prior* intentions might be understandable in terms of acting with an intention. His idea in the first article was that acting with an intention was having a reason for acting in a certain way that caused one to act in that way. He took the reason to be the combination of a relevant belief – namely, that this action is such and such a kind of action – and a relevant desire or other positive attitude towards actions of such and such a kind. He thought that there was no further state, act or disposition that was referred to by the phrase "the agent's intention"; the phrase was syncategorematic

Whatever the merits or otherwise of this approach to acting with an intention, it certainly cannot be applied directly to prior intentions (what Davidson called "pure" intentions). You can have a prior intention to do something without being caused to do it; the intention may never be realized in action. Once the causal aspect of his original theory is removed, what is left in Davidson's account of having an intention is just that the agent has a reason to act in that way. But you can have a reason to act in a certain way (consisting if you like of the belief–desire pair outlined by Davidson) without intending to act in that way. So, having a prior

intention cannot be understood in terms of acting with an intention *minus* the acting bit.

Davidson's original account of intentions with which one acts might still stand if we could accept that prior intentions were different in kind from intentions with which one acts. Then we should be happy to have two quite different accounts of the two different kinds of intention. But intending in advance to act becomes intending now to act just in virtue of the time becoming right. The intention to be acting right now is not a new and different state of mind from the prior intention. You do not have to form a new intention after you have formed a prior intention in order to have an intention with which you act. You just have to *not* change your mind.

So it seems overwhelmingly plausible that intentions with which one acts are mental states and the same sorts of mental states as prior intentions. If an account of the former cannot be applied to the latter, then it is not even a good account of the former. Davidson himself recognized this, and in his later paper substituted a different account – one that applies equally to prior intentions and intentions with which one acts. In his new account, Davidson said that intending to act in a certain way involves judging unconditionally that such a way of acting is desirable.[1]

> In the case of intentional action, at least when the action is of brief duration, nothing seems to stand in the way of an Aristotelian identification of the action with a judgement of a certain kind – an all-out, unconditional judgement that the action is desirable. ... In the case of pure intending, I now suggest that the intention simply is an all-out judgement. (1980: 99)

In his earlier account Davidson claimed that there was no entity, state, disposition or event referred to when we talk of the intention with which someone acted. In his later account he is identifying something – an all-out, unconditional judgement – that is referred to by such talk. And on the face of it he is following an inward-looking approach in this later article. Can we not understand what such a judgement is and identify such a judgement independently of having an account of intentional action, and then use this idea in order to provide an account of intentional action?

I am not so sure. In the rest of this section I want to tease out what is really meant by Davidson's idea of an all-out, unconditional judgement that an action is desirable. I am going to suggest that, despite first appearances, it turns out to be very similar to the Aristotelian idea I was testing in Chapter 7. This was the idea that achieving E with the intention to achieve E is for the achievement of E to result from the realization of a potentiality to do what you should do in order that E be achieved. This account can be applied directly to prior intentions. If acting with an intention is realizing a certain potentiality, then we can think of having that intention (whether or not you act on it) as simply having that potentiality (whether or not it is realized). This is identical with having a goal to which your behaviour is disposed to adapt.

The first thing to clarify is what Davidson meant by an *all-out* or *unconditional* judgement that some action is desirable. Davidson contrasted this sort of judgement with judging that some course of action is desirable *given* this, that and the other consideration. So I might judge that, given only the fact that I owe you ten pounds, giving you back ten pounds is the desirable thing to do. I might also judge that, given the fact that you stole ten pounds from me, keeping hold of the ten pounds you lent me is the desirable thing to do. Following the usage of the early-twentieth-century moral philosopher, W. D. Ross, Davidson describes both these judgements as *prima facie* judgements of desirability. I might also form an *all-things-considered* judgement. I might judge that given *all* the reasons available to me, the most desirable thing to do is to keep hold of the ten pounds.

But this all-things-considered judgement is still a conditional judgement. It is the judgement that *given* all available reasons this is desirable. Davidson contrasts this with an unconditional judgement simply that this is the desirable thing to do. Davidson thinks that I might judge that given all relevant considerations keeping hold of the money is best and simultaneously judge unconditionally that giving back the money is best (or *vice versa*). This possibility is the basis of his account of weakness of will, which I shall consider in the next section.

What Davidson is appealing to here is called in logic a scope shift. There is a difference between on the one hand my judging that after I thought really hard about the philosophy of action I would agree

with Davidson and on the other hand my thinking really hard about the philosophy of action and then judging that I agree with Davidson. My judgement about what attitude to the philosophy of action *would* follow from my thinking very hard does not itself necessarily follow any hard thinking. The judgement about the philosophy of action that actually would follow from hard thinking might be quite different.

In the same way, my judgement about what would be desirable if I took into account all the relevant considerations need not coincide with my judgement, which is actually based on all the relevant considerations, about what is desirable. The first is an all-things-considered *conditional* judgement; the second is an all-out or unconditional judgement.

When Davidson talks about unconditionally judging something to be desirable he means this to be incompatible with unconditionally judging some other contrary thing to be desirable too. So he means "most desirable". Indeed, I think it is quite misleading of him to talk about desirability at all since he is not trying to link these judgements with the emotion of desire. Although Davidson does not make this explicit, I interpret judging something as desirable to be the same as judging that it is *the thing to do*.

Davidson's use of the word "judgement" is quite misleading. Judgements are not states of mind as intentions are; so it looks as if this talk of judgements involves a category mistake. But what Davidson really means is that to intend to do something is to *hold* unconditionally that that is the thing to do.[2] Holding something is like believing something in the sense that both are *states* of mind, as intentions are. But it is better to talk about *holding* than *believing* in this context. Believing something must be believing something *to be true*; that such and such is the thing to do may not be something that is either true or false, and so not something that can be believed strictly speaking.

The idea of judging or holding something to be the thing to do is not to be understood in terms of some introspectively identifiable inner mental state. Davidson is quite clear that in some circumstances such judging may be constituted by actually acting (1980: 97–9). The act of switching on a light may constitute a judgement that switching on the light is the thing to do. Davidson does not spell out what he means by judging or holding. I want to suggest, on his behalf, that

your holding that switching on the light later is the thing to do means that a goal to which your behaviour is dependent and adapts is your switching on the light later. This fits the Aristotelian account I have been considering. Intentions are the goals to which behaviour adapts or, in the case of prior intentions, is merely disposed to adapt.

To intend to go to the party is to have your going to the party as your goal. This is to hold your going to the party as the thing to do. Using Davidson's slightly unhelpful language this is to judge unconditionally that going to the party is the desirable thing for you to do.

Weakness of will

According to both Davidson's earlier and his later theories of intentions and intentional action, rational intelligibility is taken to be constitutive of agency. In his earlier approach of "Actions, Reasons and Causes", intentional action requires causation by reasons. In his later approach of "Intending", intending involves judging or hold-ing that some course of action is desirable or the thing to do. This judgement reveals the respect in which the agent takes what they do to be reasonable. In acting intentionally, according to this second approach, an agent is acting according to their judgement of what they take the best course of action to be.

This fits in with the Aristotelian–Kantian approach I outlined in Chapter 2, according to which intentional action is the sort of thing that can be justified by reasons. In this approach, an agent's behav-iour counts as intentional action in virtue of being sensitive to practical justification. As I argued then, if this approach is to have any chance of success, we must allow that the system of justification embodied by any particular agent's way of behaving may be quirky, specific to the agent's perspective and include mistakes and incon-sistencies. But it would be a real challenge for this approach if, even given this very broad conception of justification, intentional action might fail to be justified. Is it possible for an agent's behaviour to be intentional and at the same time to be independent even of the agent's own system of justification? Is it possible for an agent to judge that one course of action is best according to their own conception of what counts as better or worse, and then instead of acting accord-ing to that judgement, be moved by some desire, feeling or other

emotion that is not incorporated in their system of justification, and act according to that?

Such a possibility is described by philosophers as weakness of will or incontinence. And on the face of it weakness of will is a genuine, psychologically real possibility. I might be going to bed tired or drunk and neglect to brush my teeth. I might be concerned about the state of my teeth, feel sure that it matters that I brush them every single night and morning, and know that according to the way I look at things, I should definitely brush them now. But being fully aware of all that, I cannot be bothered to do it, and go straight to bed. Likewise I might have given up smoking and resolve not to have a cigarette this evening even though all my friends in the pub will be smoking. I know I should not accept a cigarette, and I even say "I know I shouldn't" as I accept and smoke one. Peer pressure has weakened my resolve and I allow my action to be determined by how I feel at that moment rather than by my conception of how I should be acting.

These examples do not need to involve acting against any public conception of morality. As Davidson shows in his article "How is Weakness of the Will Possible?" (1980: essay 2), the teeth-brushing example can be reversed. I may get into bed feeling very sleepy and think that I should not brush my teeth tonight. If I stay in bed I shall have a good night's sleep. But getting out of bed to brush my teeth will be tiresome; I shall wake myself up and find it difficult to get back to sleep; and besides I value the feeling I am currently having. On reflection the best course of action would be to stay in bed. Still, up I get. I am moved by some feeling of guilt about not brushing my teeth instead of my best judgement as to what to do. In these cases we still describe what was done as intentional action (although the first case is trickier, being an omission not an action). But what was done fails to correspond to what should have been done, even according to the agent's own conception of what should be done. Kant's great identification of free action with rational action seems to fail with these cases of weakness of will.

In general weakness of will represents a powerful threat to the outward-looking approach to agency. It seems that, in these cases at least, what constitutes the agency – what makes the act intentional – is not sensitivity to some system of outward-looking justification, but must be the causal influence of some internal mental state: some desire or feeling. It seems that you can hold one thing to be the thing

to do and at the very same time do something else. Many people approaching the philosophy of action regard this as the decisive reason to follow a more inward-looking approach.

We have to be clear that this philosophical sense of weakness of will does not correspond exactly to the ordinary sense. In the ordinary sense to be weak-willed is to be too easily swayed, to have too little persistence and determination and to be reluctant to impose one's will on others. This is by contrast with having a "will of iron", or being strong-willed. If a strong-willed person sets their mind to something they will achieve it no matter how unpopular it makes them, how difficult it is or what its consequences turn out to be. They will not change their mind or compromise. For example, a strong-willed person who decides to stop smoking will stop smoking, while a weak-willed person will collapse at the first hurdle.

Comparing this to the philosophical sense of weakness of will, we can see that the disposition to change your mind about things is part of the ordinary notion but not the philosophical notion. If my conception of what is best to do keeps oscillating from one course of action to another, yet I always act according to what at the time I regard to be best, I am weak-willed in the ordinary sense but not in the philosophical sense. The crucial aspect of the philosophical sense of weakness of will is not that a weak-willed person changes their mind as to what is best, but that they fail to act in line with whatever they take to be best at the time. It is not that their system of justification is too easily swayed, but that their actions are too easily swayed away from their own system of justification.

Davidson describes an agent as being weak-willed if "he acts intentionally, counter to his own best judgement" (1980: 21). And he goes on to spell this out more precisely as follows: "In doing x an agent acts incontinently if and only if: (a) the agent does x intentionally; (b) the agent believes there is an alternative action y open to him; and (c) the agent judges that, all things considered, it would be better to do y than to do x" (1980: 22). Faced with apparent examples of weakness of will such as the ones mentioned earlier – examples that seem to satisfy Davidson's definition – we have a limited number of options available to us.

(i) We can argue that these examples do not really satisfy the definition of weakness of will and hold on to the claim that

weakness of will understood in this way is not a real possibility. For any apparent example of weakness of will either the agent is not really acting intentionally or they do not really judge that it would be better to do otherwise.

(ii) We can accept that the examples are good and satisfy this sort of definition, but argue that there is nevertheless a sense in which even in these cases the action is sensitive to their own conception of what is best to do. This would be to accept that the definition of weakness of will does not fully capture the idea of acting against one's own conception of what is best to do.

(iii) We can accept that the examples are good and show that it is possible for an agent to act intentionally against their conception of what it is best to do and so reject the Aristotle–Kant–Davidson identification of intentional action with action that is sensitive to reason.

Socrates, as represented in Part V of Plato's *Protagoras*, took the first option. For Socrates, knowledge of the good is all that is required for acting virtuously. So if you really know the right way to act then you act that way. Moreover even *judging* that something is the right way to act means that you must act that way; weakness of will is strictly impossible. In cases of apparent weakness of will the agent does not really judge that that is what they should do. So the weak smoker might say the words, "I know I shouldn't be doing this", but they do not mean them. They really do not know that they should not be doing this, for if they did know then they would not be doing it.

Using Davidson's terminology Socrates would say that the agent does not judge that, all things considered, it would be better to refuse the cigarette than to accept it, and if they say that it would, they are being dishonest. They have changed their conception of what it is best to do, but do not want to admit that. Aristotle describes this possibility by describing the weak-willed person as having knowledge in the sense in which having knowledge does not mean knowing but only talking as a "drunken man may mutter the verses of Empedocles" (*Nicomachean Ethics* VII: ch. 3).

Aristotle has a further diagnosis of the apparent examples of weakness of will. Sometimes you may really know what is right to do in general but fail to reason properly from this knowledge to the

particular judgement about what to do right now. So the weak smoker might judge that they should not accept a cigarette, even judge that this very action is the action of accepting a cigarette, but fail to make the logical leap to the conclusion that they should not do *this* action. So they act against their judgement of what in general it is best to do, but in accordance with their actual judgement of whether this particular action is the thing to do, and their mistake is to fail to see that a different particular judgement should follow from the general ones.

Davidson himself follows a route somewhat similar to Aristotle's. As I explained before he distinguishes between judging unconditionally that this is the thing to do and judging that given all available relevant considerations this is the thing to do. Weakness of will is possible in virtue of someone acting against their conditional judgement that this is the thing to do given all the relevant available considerations. But, according to Davidson, it would not be possible to act against an unconditional judgement of what is the thing to do.

For Davidson, the act of accepting the cigarette just is making a judgement (or at least corresponds to the judgement) that this is the thing to do, although of course not every such judgement is an action. This judgement is *based* on relevant available considerations, but is not *conditional* on them. The considerations determine the judgement but are not part of the content of the judgement.

As an analogy consider using the method of induction to form the unconditional judgement that spring will follow this winter. One can also form a conditional judgement that *if induction is correct* then spring will follow this winter. One judgement is *based* on the principle of induction; the other is partly *about* the principle of induction.

So we can see that the following things might be going on with the weak-willed person according to Davidson. They might have made a mistake concerning their conditional judgement of what is the thing to do all things considered. When they say that they should not accept the cigarette all things considered they have made a mistake; they cannot see what all the relevant considerations are very clearly. This does not get in the way of their making a good unconditional judgement that they should accept this cigarette. On the other hand their conditional judgement might be correct. Perhaps

given all the relevant available considerations accepting the cigarette is not the thing to do. But when it comes to making the unconditional judgement about whether accepting the cigarette is the thing to do the relevant considerations do not weigh with them as they should. The weak-willed person might be able to assess correctly how these considerations should weigh with them, but when it comes to these considerations actually weighing with them to yield the unconditional judgement things go wrong.

The latter sort of case looks quite plausible as a central case of weakness of will. It satisfies Davidson's definition of weakness of will but would not satisfy a stronger definition in which the weak-willed person acted against their *unconditional* judgement of what is the thing to do.

This idea can be put in the terminology of the Aristotelian account of intentional action. One goal – having a cigarette – may be what a person is disposed to adapt their behaviour to, while they do not believe that that should be their goal. They believe that, taking everything into account, smoking a cigarette is not the thing to do. But they still hold unconditionally that smoking a cigarette is the thing to do; this is the goal to which their behaviour in fact adapts.

The goal of smoking a cigarette is embedded in a system of justification. Certain circumstances would provide reasons not to have that as my goal – for example, I am in a no-smoking zone – and I would adapt and no longer have it as my goal. But, I believe that even in the current situation (even though I am not in a no-smoking zone) my goal should not be that I smoke a cigarette, and yet that is my goal. So, although my behaviour is sensitive to the requirements of a system of justification up to a point, it also reflects a lack of such sensitivity: a failure to get my goals and beliefs to be properly coherent.

Intention and commitment

Making a decision and forming an intention is like taking a stand. You plant a flag in the ground, saying "This is what I shall do; here goes". In this respect forming an intention is *committing* yourself to a certain course of action, and having an intention is being so *committed*. So the act of making a decision is not trivial or easy. In fact as we shall see later when considering the toxin puzzle there might be very odd situations in which forming an intention is much

harder than doing the corresponding action. When you have really made a decision something has changed; the very act of making the decision has consequences. When working out what to do, the difficult bit is forming the decision; there is no further tricky deliberation required to work out whether to go on to act according to that decision. Once you have made the decision you are embarked on a course of action.

Of course, when the decision is an important one it often makes good sense to revisit your decision before committing yourself even further. But this is not required in normal cases. And it is true that you can change your mind after forming an intention, and do so without letting anyone (including yourself) down. So in that respect it is unlike the sort of commitment that you have when you make a promise, for example. In particular there is no moral aspect to doing what you intend, as there is to doing what you promise.

Sensitivity to a system of justification does require that you should not change your mind after you have formed an intention without some sort of reason.[3] Something new might have come to light, you might have realized your original deliberation was defective in some way, or perhaps as a result of living with the decision for a while you have a clearer sense of its implications and like them less. But unless there is some reason for the change you should do what you intend. In this way, having an intention involves being under a commitment.

Something similar can be said for belief. Once you have decided the answer to some question, you should continue to work on that assumption unless there is reason to change your mind. You do not have to decide the answer again every time the question comes up; you are already committed to one assumption about how to answer the question and you should stick with that other things being equal.

The situation is different for mere feelings. If this morning I feel like going out tonight I am under no commitment to continue feeling like it. Unless I positively decide to go out, then there is no reason why, given that feeling this morning, I should go out when the evening comes along. If I do not have to do any planning or coordinating with others then rather than *deciding* in the morning to go out, I may think I shall see how I feel this evening. Feelings are normatively free, but intentions have some normative glue; they bind my future actions.

Now we might try to imagine someone who has no inclination to stick to their prior intentions. They are not committed by their earlier deliberations to act in any particular way later. If we can imagine such a person at all, I think we are imagining a being who has fallen to pieces as a rational agent. They cannot coordinate, prioritize and renegotiate their goals; they cannot make plans.[4]

One way to incorporate this feature of intentions would be to treat them like internal promises. To avoid the bad consequence of falling to pieces as a rational agent and never really getting anything done, we need a special mental faculty that holds us to these internal promises. Perhaps it is something like an internal solipsistic version of the guilt felt when we break an externally binding commitment. This would be the psychological glue that binds us to our courses of action and without which we would not achieve very much.

I am not convinced that we need to tell this sort of psychological story to explain why intentions bind us. I have been suggesting that having an intention involves having a certain goal driving your behaviour. This is what I take Davidson to mean when he talks about unconditionally judging that something is desirable. Before you have decided whether or not to go out tonight, it is an open question whether or not you should. The question dangles, waiting for an answer; and the answer requires a proper assessment. But once you have answered the question you now have a goal that drives your conception of what to do. Now, for all the reasons I have been outlining, it makes sense not to change your conception of what to do too quickly and for no reason. So once you have a goal you should stick to it unless there is good reason not to. And this is really all that being committed amounts to in this context.

Intention and belief

There is also a close relationship between intending and believing. When you form an intention to buy someone a present for their birthday you may say to yourself "I shall do it", and in so doing form the belief that you will. But perhaps we have to be careful here to distinguish between two judgements: the judgement that I *shall* buy a present and the judgement that I *will* buy a present.

This linguistic distinction used to be adhered to with much more rigour than it is today. Traditionally it was argued that you should

not say "I will buy a present" to express an intention, but only to make a prediction: "Usually I buy this person a birthday present, so although I have not yet decided to do so, I guess I can assume by past evidence that this year I *will* give them a present too". But when I have decided to give them a present I can say that I *shall* buy them a present. I am not predicting what will happen but stating my goal. Given this distinction we should not be too quick to jump from the fact that intending to buy a present involves judging that I shall buy a present to the conclusion that intending to buy a present involves believing that I *will* buy a present. The close connection between my intending to do something and my making a judgement about what I *shall* do does not show that the mental state of intending should be understood in terms of the mental state of belief.

Is there any link, however, between intending to buy a present and believing that I *will* buy a present? Believing that I will buy a present is believing some proposition about the uncertain future, and I might have strong reason to withhold beliefs about the uncertain future while still forming intentions about it. For example, I might intend to hit the bull's eye of a dartboard, while thinking that I shall probably fail. I do intend to hit it, and if I succeed I shall say that I hit it intentionally, but I believe I will probably not hit it.

So it seems that making something your goal does not require believing a prediction about whether that goal will be achieved. But I think this argument is not as clear-cut as it first appears. If I am really throwing the dart as a means to achieving my goal of hitting the bull's eye then I must have some belief about the efficacy of this action. I must think that carefully aiming at the bull's eye and throwing the dart is the best way to achieve my goal. And if I believe that throwing the dart in that manner is the best way of achieving the goal, this means that I believe that throwing the dart in that manner is *a* way of achieving that goal. If I believe that it is a way of achieving that goal of hitting the bull's eye, I thereby believe that it will achieve the goal, and that I will indeed hit the bull's eye.

A natural response to this argument is to say that what I really believe is not that throwing the dart in that manner *will* result in the goal of hitting a bull's eye being achieved, but that throwing the dart in that manner results in the *best chance* of achieving that goal. But this response does not work, since if my action is based merely on the belief that throwing the dart in this manner gives the best chance

of hitting the bull's eye, then my intention is not in fact to hit the bull's eye, but only to have the best chance of hitting the bull's eye.

This is quite a different intention. If I really only intended to give myself the best chance of hitting the bull's eye, then I would have succeeded in doing what I had set out to do when I threw and missed (since I would at least have succeeded in giving myself the best chance). If that were my goal, it might still make sense to feel the disappointment and to give myself a sense of failure, since presumably this would aid a conditioning process that would result in the chances of hitting the bull's eye getting even higher, but I would not have *really* failed.

Perhaps it is not after all possible to intend to achieve something while believing that one will not achieve it. And whether one accepts this or not, it is at least clear that one cannot intend to achieve something while believing that one *cannot* achieve it. I cannot intend to touch the 15-foot-high ceiling by jumping as high as I can, since I know that it is impossible for me to do it. Perhaps I may intend to make an effort in that direction or intend to act as if it were possible to touch the ceiling: to jump as high as I can with an *imaginary* goal of touching the ceiling. But I cannot make touching the ceiling my actual goal if I know it to be impossible.

It is central to any system of practical justification that if you have a goal that you discover to be unattainable you must renegotiate that goal. Intending to achieve some goal involves having a plan – albeit perhaps a very sketchy one – of how to do it. Either you are in the process of achieving the goal or at least you have such a plan. Otherwise there is no content to the idea that you are aiming at that goal or directed to it. If you believe the goal to be unattainable then you cannot have a plan, however sketchy, nor can you be simply in the process of achieving the goal.

The toxin puzzle

I want to end with a nice puzzle about intentions described by Gregory Kavka (1983), called the toxin puzzle. Imagine you are in a meeting with a multi-millionaire who offers you a million dollars to drink some unpleasant but non-fatal toxin by the end of the meeting. If you have not yet achieved your financial goals in life, you might well accept, and be a million dollars to the good. Now suppose

the multi-millionaire offers you what looks like an even better deal instead. They do not have the toxin with them now. So you do not have to drink it now, but tomorrow morning, when it will be delivered to you. And you do not even have to wait until then before you get the million dollars. If by the end of this meeting you merely intend to drink the toxin tomorrow morning, you can have the money straightaway.

You are feeling optimistic about shortly becoming a millionaire now. But in their zeal to make things easy for you the multi-millionaire may make it impossible for you. They now say to you that by the way they have no desire to see you get sick tomorrow morning and they will certainly not hold you to any obligation to actually drink the toxin in the morning; indeed, they would much rather you did not drink it. Once you have got the million dollars for intending to drink it you are completely free to change your mind and not drink it. Not only do you not have to drink it now before you get the money, but you do not have to drink it tomorrow morning either. All you have to do is to intend now to drink it then. What harm can an intention do you? It will not even make you sick, and then you can have the money. But now your delight collapses into disappointment. You cannot do it. You cannot intend to do something if you fully expect to change your mind. You know that tomorrow morning with the million dollars in your pocket and the toxin sitting in front of you you will not drink it. Why should you? And knowing this you cannot make it your goal now to drink the toxin. An intention might have seemed a small enough thing to produce to earn the money; but it turns out to be impossible. This is because when you form an intention you are committing yourself to a course of action. But it is not a commitment like making a promise, a commitment that you might know in advance you will break. It is a commitment that structures and is structured by your understanding of what will happen. Knowing that you will not drink the toxin tomorrow morning means that you cannot have the intention.

In this respect the example is similar to the multi-millionaire saying you can have a million dollars if you intend to jump ten feet into the air. It does not matter how far you actually jump; all you have to do is to intend to jump that far. You will not get the money. You cannot put intentions in your mind just by wanting to.

As a postscript for those who like happy endings, you may get the million dollars in the toxin puzzle case if you have a very nasty but honest friend. So you make a quick mobile telephone call to your friend who is a hitman and would think nothing of bumping you off as part of a contract. "Tomorrow morning I'll be at home with a million dollars in my pocket when a bottle of toxin will be delivered. I want you to be there to shoot me if I don't drink it, and then you can have the million dollars; if I do drink it, I'll give you ten grand for showing up. If I try to escape without drinking the toxin, track me down and shoot me." You would have a chance of success this way, but you would have to have a lot of trust in your nasty friend even to get the million dollars in the first place.[5]

Conclusion

The Aristotelian version of the causal theory of action holds that an agent intentionally achieves E if and only if the achievement of E results from a process that is the realization of the potentiality to produce what should be achieved in order for the agent's intended goals to be achieved. This can be applied to prior intentions just as well as to the intention with which someone acts. In this respect it is an improvement on Davidson's syncategorematic (earlier) account of the intention with which someone acts: an account that cannot be applied to prior intentions.

In this chapter I have looked at Davidson's later account of intentions, an account that applies to prior intentions and intentions with which someone acts. The idea is that to intend to φ is to judge unconditionally that it is desirable to φ. I have argued that a more helpful formulation of this account is that to intend to φ is to hold unconditionally that the thing to do is to φ. I have suggested that holding that the thing to do is to φ should not be understood in terms of some independently identifiable mental entity: a *holding*. It may be understood as having the goal of φ-ing structuring how one is disposed to behave. And this is compatible with the Aristotelian version of the causal theory of action that I have been considering.

Any such account has to say something about weakness of will. How is it possible to have the goal of smoking a cigarette now structuring how one is disposed to behave and simultaneously judging that

smoking a cigarette now is not the thing to do? I think Davidson does present a plausible story about this. One's judgement about what to do given all the relevant considerations may fail to coincide with the conception of what to do that one *actually* holds, to which one's behaviour adapts. This would be a failure of rationality, but not a complete breakdown.

On the Aristotelian account, having prior intention, even when it does not yet require action, does require *adaptability*. And this means plans must be in place. If the agent cannot construct a plan – even one as sketchy as "I'll cross that bridge when I come to it" – then adaptability fails and the intention collapses. This is why having an intention entails having certain beliefs.

9 The metaphysics of action

What is an action?

In this final chapter I want to explore the metaphysics of action. By metaphysics I do not mean anything unworldly or unobservable. The question at issue here is what sort of thing an action is if it is a thing at all. Can we identify actions with things that we have a better understanding of? Are actions identical with body movements? Or are they identical with sequences of things starting inside the agent's mind with their intentions, going through their body movements and finishing with external results being achieved? We can also ask about the spatial and temporal extent or duration of actions. Where and when are they? Do they extend beyond the body of the agent into the world around them? Do they continue after the agent stops moving or do they even continue *until* the agent starts moving?

In Chapter 5 I raised the possibility that actions are not events at all. Your action – the thing you do – is the sort of thing that is justified, not caused; whereas the process of acting in a certain way or the event of that process happening is the sort of thing that is caused, not justified. This suggests that what is justified – your action – might not have any particular identity; it might not even be an identifiable particular. And then it would be inappropriate to ask the metaphysical questions I have just raised about its identity.

Even if that is right, however, we can still ask these metaphysical questions about particular *processes* of acting in certain ways. For the sake of ease of expression, I shall talk about actions when I mean such processes of acting, while accepting that these processes are not themselves things one *does*.

What is meant by "by"?

Very often when we do something we do it *by* doing something else. For example you might illuminate a room by turning on the light and you might turn on the light by pressing the switch; and you might press the switch by moving your finger in a certain way. Whether we can go any further than this is a moot point that I will consider later. Jennifer Hornsby (1980) has argued that we can go one stage further. She claims that you move your finger by *trying* to move your finger. But there must be a limit to this unpacking of an action in terms of how it is done. At some point there will be a basic action that you do without doing something else. So in this way the simple action of illuminating a room can be seen to involve doing a number of different things. We can see layers of action inside the action. And the action can be stretched in the other direction too. Perhaps you enabled yourself to see things in the room by illuminating it. And there will be various accidental consequences of your action that you achieve by this. So you revealed the true horror of the mess in the room by enabling yourself to see things in it. And by revealing the true horror of the mess in the room you gave yourself a nasty shock. And so it might go on.

When we say that you do *A* by doing *B* we mean that doing *B* was the *way* you did *A*. It is an answer to the question "How?": "How did you illuminate the room?" "By switching on the light." So, saying how you did something is spelling out the way you did something, and we use the word "by" to do this.

Anscombe (1957) and Davidson (1980: essay 3) have argued that when we do spell out the way someone acted using the word "by" we are simply redescribing the same action rather than describing a different action. The distinction between thinking of an action as the thing done and thinking of the action as the process of doing it is important here. It is plausible that *what* you do in illuminating the room is different from *what* you do in pressing the light switch. The results or achievements are different and would require different justifications. But the question at issue here is whether the processes are different. Is your action of illuminating the room a different process from your action of pressing the light switch? It seems plausible that it is not. For example, we do say, "Your pressing the light switch just *is* your illuminating the room."

Quite a bit of the discussion of the metaphysics of action depends on this point. So it is worth labouring it a bit. For Anscombe and Davidson there are not five different intentional actions (by which they mean processes of acting); your moving your finger; your pressing the light switch; your turning on the light; your illuminating the room; and your enabling yourself to see things in the room. There is just one action and five different descriptions of it. And of course there are indefinitely many more descriptions of it. It was your doing the first thing you normally do on entering that room. It was your doing the thing we are discussing now. It was your dramatically increasing the number of photons in the room. And so on.

Some answers to the question of how you did something might involve merely redescribing the achievement rather than describing the action in terms of a different achievement. In these cases it is quite easy to accept that what is being described is the very same action. For example, suppose that the oak tree is the highest tree in the park. Then what I do when I climb the oak tree is exactly the same as what I do when I climb the highest tree in the park. So the process of my climbing the oak tree is the very same as the process of my climbing the highest tree in the park. In these cases we can use the word "by" *symmetrically*. I climbed the highest tree by climbing the oak tree. And at the same time I climbed the oak tree by climbing the highest tree.

But sometimes spelling out a way of doing something involves more than just redescribing the thing achieved. In particular it might involve spelling out a causal route: "How did you get from Manchester to Oxford?" "By first taking the train from Manchester to Birmingham New Street, then walking to Birmingham Moor Street, then taking a train from Birmingham Moor Street to Banbury, then changing on to the Oxford train and staying on it until it reached Oxford." It is worth noting that here the word "by" is not used symmetrically. It does not sound right to say that I did that sequence of things by going from Manchester to Oxford. When one spells out the means by which one thing is done it must be in a way that might in theory help someone who had that goal but did not know how to achieve it. If my goal is to climb the highest tree then it might help to know that I need to climb the oak tree. And if my goal is to climb the oak tree it might help to know that I need to climb the highest tree. If my goal is to go from Manchester to Oxford it might

help to know that I can do it by first taking the train to Birmingham and so on. But if my goal is to take the train from Manchester to Birmingham New Street, then walk to Moor Street and so on, it is not helpful to be told that I should go from Manchester to Oxford.

Identity itself is a symmetrical relation: if $A = B$ then $B = A$. So does the lack of symmetry in the use of "by" show that the action of my going from Manchester to Oxford is not identical to the sequence of actions spelled out in the answer? No, because the word "by" does not link references to actions as such. We do not say that the process of my going from Oxford to Manchester was by the process of my first taking the train to Birmingham and so on. So it is very misleading to say, as some philosophers have, that Anscombe and Davidson claim that the by-relation is one of identity. The proper way to put their claim is that when an agent φ-s by ψ-ing, their φ-ing is the very same process as their ψ-ing. Their claim is that the process of my going from Manchester to Oxford is the very same process as the overall sequence of processes spelled out in saying how I did it. My going from Oxford to Manchester just was my taking the train from Manchester to Birmingham New Street, walking to Moor Street and so on. And the same can be said the other way round. My taking the train from Manchester to Birmingham New Street, walking to Moor Street and so on just was my going from Oxford to Manchester.

This certainly sounds reasonable, and the case can be made stronger by arguing against alternative ways to understand the use of the word "by". The two obvious alternatives are these:

- the causal interpretation – when an agent φ-s by ψ-ing, the process of their φ-ing *causes* the process of their ψ-ing;
- the part–whole interpretation – when an agent φ-s by ψ-ing, the process of their φ-ing is *part of* the process of their ψ-ing.

The causal interpretation is attractive because it is true that very often when we describe how someone did something we spell out the causal route. When you turn on the light by pressing the switch, your pressing the switch does indeed cause the light to go on. But we have to be very careful here of the distinction between the result that is achieved in an action and the action or process of acting itself. For it sounds horrible and is certainly not obviously true to say that

your pressing the switch causes *your turning on* of the light. This would be to say that your causing the switch to be pressed causes your causing the light to go on. But this does not sound right. Even if the light going on (the result of your action) does result from your causing the switch to be pressed, your *causing* the light to go on (the process of achieving that result) does not.

Once we have sorted out this distinction there should be no temptation to say that when an agent φ-s by ψ-ing, the process of their φ-ing causes the process of their ψ-ing. So what about the part–whole interpretation: the claim that when an agent φ-s by ψ-ing, the process of their φ-ing is *part* of the process of their ψ-ing? It sounds much less horrible to say that your causing the switch to be pressed is part of your causing the light to go on.

There is certainly something right about this part–whole interpretation. I go from Manchester to Oxford by first taking the train from Manchester to Birmingham New Street. But my taking the train to Birmingham is certainly not the same process as my going to Oxford. It is *part* of that process. However this is due to the fact that we have only *partially* spelled out the way to go from Manchester to Oxford. When the whole way is spelled out it no longer looks plausible that this is only part of the process of going from Manchester to Oxford. There is nothing more to my going from Manchester to Oxford than my taking the train to Birmingham New Street then walking to Moor Street and so on.

The case is less clear in the example of turning on the light. When you have finished pressing the switch there is nothing more you have to do. The way you turned on the light is fully specified by saying you pressed the switch. But it might be thought that there is still something more to your turning on the light than your pressing the switch. After all the light is not yet on until the element in the light bulb has heated up. Between the closing of the circuit in the switch and the light going on there is a very small time gap. This may suggest that your pressing the switch is not the whole process of your turning on the light but only part of it.

Another example may make the challenge to the Anscombe–Davidson claim clearer. Lee murders John by shooting him.[1] He does this by pulling the trigger on his rifle. After he pulls the trigger he does not have to do anything else. That is the whole of the way he does the killing, not merely the first part. Yet when he has finished

pulling the trigger he has not yet killed John. The bullet has only just started on its way, and John may die a couple of hours later in hospital. John is not killed until he dies, but Lee has finished pulling the trigger long before. So if John's dying is part of Lee's action of killing John then Lee's action of pulling the trigger is not the whole of his action of killing John but only part of it.

It seems as if Lee's way of killing John – the means *by* which he does it – is not the whole action of his killing John but only part of it. But we can defend Davidson's position in the following way. An action cannot consist of one part that is an action and another part that has nothing essentially to do with the agent or their agency. If we construct a compound of an action and something that has nothing essentially to do with the agent's agency then the whole of their action consists in the first part of the compound. In the case of Lee killing John we can identify the action of Lee pulling the trigger. But after that he is no longer acting; the rest is up to nature. The process of the bullet flying followed by the man being hit by the bullet and dying happens without any contemporaneous involvement of Lee. He is causally responsible for that process, but his work is done as soon as the process begins. The very same process could occur without Lee having been the initiator of it. So that part of the process after Lee has finished squeezing the trigger involves none of his agency essentially, and so is not part of his action.

Certainly this argument can be rejected. We might say that the process of an agent doing something may involve parts that do not essentially involve the agent as well as parts that do. Lee might look at the bullet flying through the air and say, "I'm doing that; I'm making that happen." But perhaps Lee should properly say, "I *did* that; I *made* that happen." If there is no contemporaneous involvement of the agent we cannot say that he is *doing* anything. This thought takes on more force when we imagine Lee having a heart attack and dying himself just as he squeezes the trigger. Is he still killing John even after he is dead? Or does it make more sense to say that with your death comes the end of your agency? But the scope of the process of Lee's acting is the same whether or not he himself dies after the trigger has been squeezed. So if what is going on in the hospital with John is no part of what Lee is doing when he is dead, it is no part of what he is doing when he survives either.

If I bury a cask containing a year's harvest of toenail clippings in the back garden I may indeed be causing archaeologists in the year 3000 to be perplexed. But it is not in the year 3000 that I am doing the causing; I am doing the causing now. What happens in 3000 is the *result* of my agency not *part* of it. It might seem bizarre to say that Lee might finish his action of killing John long before John is dead. But it is not really bizarre. According to Davidson's analysis it is not an essential aspect of the process of Lee killing John that John is killed; it is only an essential condition of the *description* of what Lee does as a killing. He might have acted in the very same way and it not been a killing.

I have more or less reiterated Davidson's argument against the idea that Lee's squeezing the trigger is one part of his action and John's dying is another part. It does not follow straightaway that when an agent φ-s by ψ-ing, their φ-ing is the very same process as their ψ-ing, since the relation between their φ-ing and their ψ-ing might be something other than either identity, a causal relation or a part–whole relation. But I propose for the sake of argument to accept the Anscombe–Davidson thesis that it is identity and consider the implications.

Basic actions

The implications of the Anscombe–Davidson thesis depend on what is the sort of description you arrive at if you keep asking, "How did the agent φ?" "They φ-ed by ψ-ing." "How did they ψ?" "They ψ-ed by ξ-ing." And so on. It must end somewhere. Let the description of what they do where there is no further specification of a way of doing that be called a *basic* description of their action. We might say that such a description describes a *basic* action. But if Anscombe and Davidson are right, this phrase would be a bit misleading since *all* actions would be basic (since they would all be identical to the basic action). Their point would be that actions can be described in more or less basic ways. So there are basic *achievements* of action: things achieved that are not achieved by doing anything else. And there are basic *descriptions* of actions: descriptions in terms of basic achievements. But whether there is a hierarchy of more or less basic *actions* depends on whether Anscombe and Davidson are right that the process of doing one thing is the same as the process of doing something by doing it.

Davidson claims that usually the basic achievements of action are movements of the agent's body. You illuminate the room by turning on the light. You do that by pressing the light switch; and you do that by moving your finger in a certain way. And there is nothing more basic you do in order to move your finger in that way; you just move it. If this were generally true then all actions would be body movements; and describing an action as a body movement or structure of body movements would be providing the basic description of the action.

We have to be very clear about the distinction made earlier in the book between transitive movements and intransitive movements. We must distinguish between the process of an agent moving their finger and the process of their finger moving. The first is a transitive movement and the second is an intransitive movement. When Davidson identifies all actions with body movements he should be identifying actions with transitive body movements (although this is not always very clear). You do not press the light switch by your finger moving (intransitively). You press the light switch by moving your finger (transitively). So identifying actions with body movements does not mean that everything you do is just your body moving. It means that everything you do is just moving your body.

Davidson's claim has implications for the spatial extent and temporal duration of actions. It means that actions never extend beyond the skin, but always extend that far. And it means that actions never last for a split second after the body stops moving, since your moving your body does not continue after your body stops moving. Lee's action has finished when his finger stops moving. He is killing John up to that point and not beyond. Whatever happens outside the body and after the body stops moving is not essential to the identity of any process of acting, although it may well determine the most appropriate way to *describe* the action.

Are body movements our basic achievements?

There are various ways to challenge Davidson's claim that basic descriptions of action describe body movements. I shall consider in turn the possibility of mental actions that involve no body movement, the possibility of actions that essentially involve the world outside the agent's body and where there is no more basic description

of the action that makes no reference to this external world, and finally the possibility that every action of moving part of one's body is done by doing something else even more basic; namely, by *trying* to move one's body in that way.

I think it is unquestionable that we can act without moving our bodies as such. Calculating a sum in one's head is acting; it is doing something; it involves one's agency; and it results in an achievement, although the achievement is just that one's state of knowledge is improved.

One might try to argue that calculating something is done by moving one's brain around: that is, by changing the strengths of connections between various neurons. But although the brain does indeed change in this way when you perform a calculation in your head, you do not change your brain as a way of calculating the sum. It is an intransitive change not a transitive one. Describing what happens in your brain is not describing your action; it is describing some physical change that your action depends on. You have no intentional control over these neuronal connections. So it would be a mistake to say that you do a sum by moving or changing your brain. I think Davidson would say that these cases of mental acts were just exceptions to the general principle that actions are body movements. He would be more worried if there were actions where the most basic description made essential reference to the world *outside* the agent's body. And I think there are such actions; indeed, almost all actions are like this.

Consider a musician playing a note on a trumpet. They do this by pursing their lips in a certain way against the mouthpiece and blowing so that the lips vibrate against the mouthpiece. Now you can practise this movement without a trumpet, performing what is technically known as a raspberry. But this is not exactly what you do with the trumpet since the pressure of the trumpet against your lips slightly alters the required movements. This means that describing what you do just in terms of vibrations of the lips does not properly describe the action. The action, like so many others, essentially involves responding to pressure; and this is not a mere body movement. This goes for any action involving skill with an object. You do not ride a bicycle just by moving your body in a certain way. You have to be on the bicycle to move in the right sort of way. And that part of the movement that keeps you balanced cannot be described except in

terms of your orientation with respect to the direction of gravity, the force of gravity being something outside your body.

I think the whole idea of a body movement is a bit dodgy. Walking is moving your body (as is cycling or catching a train). But what is presumably meant when philosophers talk of one's body moving as the basic achievement in action is that the parts of one's body moving relative to each other is the basic achievement. This would be a body movement that could be described with no reference to anything outside of the body. But even putting one foot in front of another in the act of walking along is more than just causing one part of the body to move in relation to another. For the foot is being placed down on the ground and the leg is pushing back against the ground, something you could not do if there were no ground to push back against. If you were in outer space pretending to walk, this would involve you in a different process of acting with different results being achieved.

And when it comes to more complex actions such as writing a book or catching a bus into town it is even more absurd to think that we can describe the way to do these things in terms of moving your body parts in relation to one another. The process of acting is almost always a feedback process. It is not just a process of emitting or outputting behaviour by moving the body parts; it essentially involves responding to the success or failure of these body movements and adapting accordingly. Even a simple action such as squeezing a trigger is not done by moving your finger in a certain way. It is done by beginning a movement and adapting further movement to feedback from the result of that first movement, pulling harder until the trigger starts to move and then maintaining that pressure until the trigger is released.

So Lee did not kill John by moving his finger. He shot John by first aiming his rifle at him. This part of the action could not be described in terms of a mere body movement. John must figure in any description of an aiming-at-John action. Squeezing the trigger is not a mere body movement either. And finally, unless Lee is merely *taking a shot* at John, the action may also involve watching to see the result of the shot, and firing again if it misses. This means that the process of Lee killing John may continue after Lee has stopped moving his finger. It lasts until he sees he has succeeded and he has stopped any further action.

Trying

Hornsby (1980) does not question Davidson's assumption that actions are generally movements of the body, as I have done. What she questions is whether we can go further and describe actions in even more basic ways. She has argued that even the movement of the body is incidental to an action; the very same process might happen without the body moving at all. What *is* essential according to Hornsby is the agent's trying to move their body that way. So, when asked how you illuminated the room, and how you did that, and how you did that, the last answer is not that you did it by moving your finger in a certain way. For you did that by *trying* to move your finger that way.

There are several different claims Hornsby is making here. One is that in acting in a certain way the basic description of the action should be in terms of trying. Whenever you do something you do it by trying to do it. Since Hornsby accepts the Anscombe–Davidson claim that your action of doing something is identical to your action of doing whatever you do by means of which you do that thing, she concludes that all actions are actions of trying. This is the second claim.

A third claim she is making is that tryings (and therefore actions) are interior to body movements. They occur before the body movements and cause the body to move. So whereas Davidson argues that actions do not essentially involve any effects beyond the body's movements, Hornsby makes the even more radical claim that actions do not essentially involve the body movements.

I shall look at these claims in turn. First of all, is it true that for everything we do we do it by trying to do it? That you have to try to act in a certain way in order to act in that way sounds like the idea that every action must be preceded by an act of will; this is volitionism. But it is important to see that Hornsby is not committed to the idea that every act is preceded by an act of will. That is because, like Davidson, she *identifies* the action of doing something with the action that is your way of doing it: that *by* which you do it. So if you act by trying to act, the act just is the trying to act. The trying does not precede the action; it is identical to the action. This way the regress argument against volitionism does not get going.

The idea that every action involves trying to act may still sound strange and implausible. Very often one does not have to try in order

to achieve something; one just does it. I can pick up a pen in front of me without any effort at all. I just do it. I do not set myself to do it, grit my teeth and make an effort. Without even thinking about it I pick it up. But Hornsby argues (1980: 34ff.) that whenever you say that you did something without trying you do not literally mean that you did not try. If someone asks me what I was trying to do by moving my hand in that way against the pen, it is natural for me to say that I was trying to pick up the pen. Or suppose the pen is incredibly slippery and slips out of my fingers just as I was picking it up. I was at any rate trying to pick up the pen. But I was making no extra effort in that case than I was in the case when the pen was not slippery. So even in the case where the pen is not slippery and I succeeded in picking it up I must have been trying to pick it up too.

Trying to achieve some goal should be understood as doing what one should do or at any rate thinks one should do in order to achieve that goal. When you do one thing by doing another you are doing what you take to be what you should do in order to do the first thing. So it follows trivially that you are doing it by trying to do it. For basic actions where there is nothing else you do in order to do something, you are still doing what you take to be what you should do to do it; namely, doing it. What I should do in order to raise my finger is just to raise my finger. So my raising my finger and my trying to raise my finger are the same thing. This means that Hornsby's claims that you do things by trying to do them and that every action is an act of trying are quite reasonable. What is much more controversial is her third claim that tryings and actions are interior processes causally preceding body movements.

Certainly it is not immediately obvious that actions of trying to do things are all interior mental events. Suppose I try to burn a pile of leaves at the bottom of my garden by first lighting some kindling wood in the hope (vain hope as it turns out) that the burning kindling wood will set the leaves on fire. My trying to burn the leaves consists in my actually burning some kindling wood. And it cannot be taken for granted that my actually burning the kindling wood is a mental action, causally prior to any body movements.

Hornsby's argument here comes in two stages. First she argues that for those actions that are body movements, the process of trying to move the body (and so at the same time the process of actually moving the body) must causally precede the actual body movement. Then she

says (1980: 45) that it would be strange if a whole class of actions – namely, movements of one's body – were mental events causally prior to the body's actually moving, while another class of actions – those, if any, that are not movements of the body – occur outside the mind and are not causally prior to the body's moving. So it is most plausible to think that all actions are causally prior mental events.

If my criticism of Davidson's claim that actions are generally movements of the body is correct, however, the class of actions that are movements of the body may turn out to be a very limited class. Perhaps it is a very unusual case to move only one part of your body with respect to another. In the normal case, acting essentially involves the world outside one's body. If this is right then even if Hornsby were right to say that actions of moving one's body were causally prior to the body actually moving, it would not seem strange if other actions were not causally prior to the agent's body moving. The causally prior ones would be the exceptional cases, not the normal cases.

Is Hornsby right even to say (1980: 13) that actions of moving one's body must be causally prior to one's body moving? One of her arguments for this claim is based on the assumption that the process of an agent making something happen causes that thing to happen. My moving (transitively) my little finger causes my little finger to move (intransitively). So my action of moving my little finger is causally prior to the actual intransitive movement. It is further back in the causal chain: an internal mental event. But I think we should be very careful to clarify the sense in which my action of moving my little finger causes my little finger to move. A process may result in some outcome just in virtue of that outcome *belonging* to the process. The process of the seawater washing away a sandcastle causes the sandcastle to be washed away, but it is not *prior* to the sandcastle being washed away. The sandcastle's collapse into the sea belongs to that process. In the same way the finger moving (intransitively) belongs to the process of the agent moving their finger: not something that happens afterwards.

Here I am assuming an Aristotelian rather than a Humean approach to causation. In the Humean approach, if A causes B then A and B must be separate events: A prior to B. In the Aristotelian approach, A might cause B by being an input into some process (realization of a potentiality) that results in B. In this case we may also say that the process causes B. But as the sandcastle example shows,

the process is not prior to the result B; B belongs to the process. An agent moving their finger is not an input into a process that results in their finger moving. It is itself a process that results in their finger moving. And it does this because the movement of the finger *belongs* to that process.

Another of Hornsby's arguments for the claim that moving your body and trying to move your body are causally prior to your body moving mirrors Davidson's argument for the claim that actions are causally prior to their intended effects beyond the body. The argument may be spelled out as follows:

1. You can try to move your body and your body fail to move due to some unforeseen nerve difficulty. In this case your trying to move your body does not involve your body actually moving.
2. But as far as your agency is concerned, this is the same as when you succeed: that is, that bit that is up to you is the same while the rest is up to nature.
3. So even in the successful case the trying (and the action) does not essentially involve the body moving.

Imagine raising your finger. Now imagine that your finger is paralysed and cannot be moved, but that you are getting misleading nerve signals that give you the impression that you have successfully moved it. Assumption (1) is that in this case you at any rate try to move your finger. This assumption could certainly be denied. You may be under the impression that you have tried to move your finger. But if you have done nothing at all is it obvious that you have so much as tried? But even if we accept this, I do not think it is clear that your trying to move your finger in this odd case is the very same process as your actually moving your finger in the normal case: assumption (2). It is true that you are at the time not aware of any difference between the two processes. But this by itself does not make them the same. So the second assumption is not clearly true either.

Conclusion

The Anscombe–Davidson claim that Hornsby also accepts is that when you describe how you acted by saying "I φ-ed by ψ-ing," you

are redescribing one and the same action. I have not found any over-whelming arguments for this. But it certainly looks plausible and I can find no good reason to reject it.

It follows from this that if you do every action by moving your body in a certain way then Davidson is right and every action is your moving your body. It also follows that if you do every action by trying to do it then Hornsby is right and every action is an act of trying. But I have given some reasons to doubt Davidson's claim that you do everything by moving your body in a certain way. Acting involves attending, looking, listening, feeling, and so on, as well as moving. It is a complex process involving feedback from the world, and in even the simplest cases appears to be more than simply moving body parts relative to one another.

Hornsby's claim that you do everything by trying to do it seems more reasonable. But if we have rejected Davidson's claim that every action is a body movement then we cannot infer from Hornsby's claim that every act is an act of trying to move your body in a certain way. This means that we do not have to accept that actions causally precede the body moving. For those acts that *are* acts of trying to move your body in a certain way, your action does cause your body to move in some sense. But this does not mean that your trying to move your body happens first and then your body moves. Your body moving belongs to the process of your trying to move your body just as the sandcastle collapsing into the sea belongs to the process of the sea washing the sandcastle away.

Conclusion

Back in Chapter 1 I introduced a distinction between an inward-looking and an outward-looking approach to agency and action. In Chapter 2 I described a rationalistic approach to agency according to which what characterizes intentional action is that it is subject to justification. In Chapter 3 I argued that the reasons that figure in the justification of action are generally considerations in the world outside the mind of the agent. This means that the rationalistic approach to agency is still an outward-looking approach.

Then I tried to work out how to characterize the causal aspect of agency. In Chapter 4 I tentatively accepted the principle that when someone acts they *make* something happen in the world. Combined with the rationalistic approach this means that an action is a causal process of making something happen in the light of certain reasons. Acting is justified causation.

I was not convinced by the agent-causationist claim that someone making something happen should not be understood in terms of some state they are in being causally significant. But I was not convinced either that it should be understood in terms of some internal psychological state being causally significant. I considered various arguments in Chapter 5 against the idea that psychological states do cause the results of action, and found none of them particularly convincing either.

What does seem clear, however, is that we cannot provide a constitutive account of what action is in terms of psychological states causing things. Deviant causal chains show that a proper account of action must say something not just about the cause and effect in

action but about *how* the effect is caused. With this in mind I introduced an Aristotelian approach to causal processes in Chapter 6. This led to the following theory of action:

> An agent intentionally acts if and only if the result of their action results from a process that is the realization of the potentiality to produce what is justified according to some system of justification.

Having such a potentiality is tied up with being an agent. Indeed, it might be interesting to explore the reductive account that simply *identifies* an agent with a potentiality to produce what is justified according to some system of justification.

This theory combines the rationalistic approach to agency with a causal treatment understood in an Aristotelian way. It can be turned into an account of intention with which someone acts as follows:

> An agent intentionally achieves E if and only if the achievement of E results from a process that is the realization of the potentiality to produce what should be achieved (according to some system of justification) in order for E to be achieved.

This gives an account of intentions generally (whether acted on or not) as follows:

> An agent has the intention to achieve E if and only if they embody the potentiality to produce what should be achieved (according to some system of justification) in order for E to be achieved.

In Chapters 7 and 8 I defended this sort of approach to intentions against more inward-looking approaches. And in Chapter 9 I defended the conception of an action as a process involving rational sensitivity to considerations in the world against inward-looking conceptions in which actions are identified with body movements or with mental events of trying.

My conclusion is that wherever you can identify causal processes that are sensitive to the recommendations of systems of justification, there you have found agency.

Notes

Chapter 1. Introduction: inward-looking and outward-looking approaches to agency

1. The sunflowers of my experience do not turn to follow the sun throughout the day, as they are often supposed to, but simply bloom on the eastern side of the stem. They might equally be described as turning their backs on the setting sun; but this is all beside the point.
2. This idea was worked out by the developmental psychologist, Jean Piaget, in the 1920s and 1930s.
3. As we shall see in Chapter 7, this can be denied. But we can accept it for the time being.
4. This claim about reasons being provided by the world outside is controversial. I shall examine it in some detail in Chapter 3.
5. This external conception of the mind is argued for by Greg McCulloch, *The Mind and its World* (London: Routledge, 1995).

Chapter 2. Acting for a reason

1. I should repeat that I am using the word "justification" in the weakest possible sense. In this sense the fact that your husband has a healthy life insurance policy can justify your murdering him. As I shall explain later, this is to work with a notion of *relative* justification: justification given a *system* of justification. In an *absolute* sense the wife's act of murder is not justified of course.
2. Elliott Sober, *The Nature of Selection* (Cambridge, MA: MIT Press, 1984) provides a good account of this distinction between developmental and selectional explanations.
3. See for example J. Dancy, *Ethics without Principles* (Oxford: Oxford University Press, 2004).
4. See F. Lyotard, *The Postmodern Condition* (Manchester: Manchester University Press, 1984) for a classic defence of the postmodernist stance.
5. See for example Hegel's *Science of Logic*, A. V. Miller (trans.) (London: George Allen & Unwin, 1969), ch. 8.

Chapter 3. Reasons and passions

1. I am deliberately remaining vague at this stage about what I take this notion of *commitment* to a system of justification to amount to. I shall start to examine this in Chapters 4 and 5.

2. A. Mele, *Motivation and Agency* (Oxford: Oxford University Press, 2003), ch. 1 has a good treatment of the different ways we understand the idea of motivation.

3. D. Hume, *A Treatise on Human Nature*, P. H. Nidditch (ed.) (Oxford: Oxford University Press, 1975), 457.

4. Hume usually talks about *morals* or moral *distinctions* rather than moral *judgements*; but let us assume that is what he means.

5. I. Kant, *Groundwork: The Moral Law* (London: Hutchinson, 1965), 66–7, T. Nagel, *The Possibility of Altruism* (Princeton, NJ: Princeton University Press, 1970), 29–30 and J. McDowell, "Are Moral Requirements Hypothetical Imperatives", *Proceedings of the Aristotelian Society*, supp. vol. 52 (1978), 13–29, esp. 15.

6. Hume's own position moderated later on to incorporate the Aristotelian idea of refining one's taste and sensibility, so that particular emotions were taken to be assessable by reference to something outside them. See his essay "Of the Standard of Taste" in *Selected Essays*, S. Copley & A. Edgar (eds), 133–53 (Oxford: Oxford University Press, 1998).

Chapter 4. Agent causation

1. See, for example, Jennifer Hornsby, *Actions* (London: Routledge, 1980), 13ff., although the distinction goes back through the philosophy of action literature to Aristotle.

2. This is the way Elizabeth Anscombe argued. See *The Collected Philosophical Papers of G. E. M. Anscombe, II, Metaphysics and the Philosophy of Mind* (Oxford: Blackwell, 1981), 137.

3. This version is very like that of David Pears, "Sketch for a Causal Theory of Wanting and Doing", in *Questions in the Philosophy of Mind*, 97–141 (London: Duckworth, 1975).

4. The two most cited sources of the theory of agent causation in recent times are Roderick Chisholm, "Freedom and Action", in *Freedom and Determinism*, K. Lehrer (ed.), 11–44 (New York: Random House, 1966) and Richard Taylor, *Action and Purpose* (Englewood Cliffs, NJ: Prentice Hall, 1966). More recently Timothy O'Connor, *Persons and Causes: The Metaphysics of Free Will* (Oxford: Oxford University Press, 2000) has defended what he calls agent causation. It is important to see that each of these philosophers means something slightly different by the name.

5. This sort of worry – often called *Hume's fork* – applies to any indeterministic accounts of free will, whether agent-causal accounts or indeterministic event-causal accounts. A thorough treatment of a variety of such accounts may be found in Randolph Clarke, *Libertarian Accounts of Free Will* (Oxford: Oxford University Press, 2003).

6. See E. Anscombe, *Causality and Determination* (Cambridge: Cambridge University Press, 1971).

7. This is what Clarke suggests in his account that attempts to integrate agent and event causation in *Libertarian Accounts of Free Will*, ch. 8.

Chapter 5. Mental causation

1. See, for example, John Hyman, "-ings and -ers", *Ratio* 14 (2001), 298–317.
2. This argument is found in A. Melden, *Free Action* (London: Routledge, 1961), 52, as well as Georg von Wright, *Explanation and Understanding* (London: Routledge, 1971). A good treatment of it is in Fred Stoutland, "The Logical Connection Argument", *American Philosophical Quarterly* 7, monograph no. 4 (1970), 117–29.

Chapter 6. Deviant causal chains and causal processes

1. See S. Mumford, *Dispositions* (Oxford: Oxford University Press, 1998) for at least one well worked-out approach.
2. See R. Harré and E. Madden, *Causal Powers* (Oxford: Blackwell, 1975) for an excellent treatment of an Aristotelian approach to causal powers.
3. This is quite like the account of reasons-responsiveness developed by J. Fischer and M. Ravizza, *Responsibility and Control* (Cambridge: Cambridge University Press, 1998).

Chapter 7. Acting with an intention

1. This talk of "achieving E" is mine not Davidson's. I am also describing the account as providing both necessary and sufficient conditions of intentional action; but Davidson acknowledges in a later paper that the problem of deviant causal chains blocks the account from providing a sufficient condition. This would also block it from providing the basis of an account of what it is to act with an intention.
2. The example is developed in J. Bennett, *The Act Itself* (Oxford: Oxford University Press, 1995), 196ff.
3. See M. Bratman, *Intentions, Plans and Practical Reason* (Cambridge, MA: Harvard University Press, 1987), ch. 10.

Chapter 8. Prior intention

1. Davidson also took the problem of deviant causal chains to be an insurmountable objection to his earlier account.
2. See D. Davidson, *Essays on Actions and Events* (Oxford: Oxford University Press, 1980), 97 n.7.
3. Note that the word "should" is not being used here in a moral sense.
4. Bratman, *Intentions, Plans and Practical Reason* has a very good account of the function intentions serve in coordinating action and making plans.
5. Kavka explicitly rules out this possibility, unfortunately.

Chapter 9. The metaphysics of action

1. When discussing action the philosopher's mind usually turns to murder. I have quite consciously limited my use of murder in examples, although I am afraid it still crops up rather often.

Suggestions for further reading

Much contemporary philosophy of action is carried out in blissful ignorance of the history of the subject, but I think some of the deepest issues can only really be understood by delving into the past.

Classic pre-twentieth century texts

Aristotle, *Physics*, book 2, *Nicomachean Ethics*, especially book 3, *de Motu Animalium*, *de Anima*, book 3.
Descartes, *Passions of the Soul*.
Spinoza, *Ethics*, books 3–5.
Locke, *Essay concerning Human Understanding*, book 2, chapter 21.
Hume, *Treatise on Human Nature*, book 2, part 3.
Reid, *Essays on the Active Powers*, essay 1.
Kant, *Groundwork of the Metaphysics of Morals*.

Some important texts of the latter half of the twentieth century

Anscombe, E. 1957. *Intention*. Oxford: Blackwell.
Audi, R. 1993. *Action, Intention and Reason*. Ithaca, NY: Cornell University Press.
Bennett, J. 1995. *The Act Itself*. Oxford: Oxford University Press.
Bratman, M. 1987. *Intentions, Plans and Practical Reason*. Cambridge, MA: Harvard University Press.
Bratman, M. 1999. *Faces of Intention*. Cambridge: Cambridge University Press.
Davidson, D. 1980. *Essays on Actions and Events*. Oxford: Oxford University Press.
Ginet, C. 1990. *On Action*. Cambridge: Cambridge University Press.
Hornsby, J. 1980. *Actions*. London: Routledge.
Kenny, A. 1963. *Action, Emotion and the Will*. London: Routledge.
McCann, H. 1998. *The Works of Agency*. Ithaca, NY: Cornell University Press.
Melden, A. 1961. *Free Action*. London: Routledge.
Mele, A. 1992. *Springs of Action*. Oxford: Oxford University Press.
O'Shaughnessy, B. 1980. *The Will*. Cambridge: Cambridge University Press.

Taylor, C. 1964. *The Explanation of Behaviour*. London: Routledge.
Velleman, D. 1989. *Practical Reflection*. Princeton, NJ: Princeton University Press.

Some good introductions and readers

Davis, L. 1979. *Theory of Action*. Englewood Cliffs, NJ: Prentice Hall.
Moya, C. 1990. *The Philosophy of Action*. Cambridge: Polity.
Mele, A. (ed.) 1997. *The Philosophy of Action*. Oxford: Oxford University Press.
Raz, J. (ed.) 1979. *Practical Reasoning*. Oxford: Oxford University Press.

References

Anscombe, E. 1957. *Intention*. Oxford: Blackwell.

Anscombe, E. 1971. *Causality and Determination*. Cambridge: Cambridge University Press.

Anscombe, E. 1981. *The Collected Philosophical Papers of G. E. M. Anscombe, II, Metaphysics and the Philosophy of Mind*. Oxford: Blackwell.

Aristotle 1984. *Complete Works of Aristotle*, J. Barnes (ed.). Princeton, NJ: Princeton University Press.

Audi, R. 1993. *Action, Intention and Reason*. Ithaca, NY: Cornell University Press.

Bennett, J. 1995. *The Act Itself*. Oxford: Oxford University Press.

Bratman, M. 1984. "Two Faces of Intention". *Philosophical Review* 93, 375–405.

Bratman, M. 1987. *Intentions, Plans and Practical Reason*. Cambridge, MA: Harvard University Press.

Bratman, M. 1993. "Shared Intention". *Ethics* 104, 97–113.

Broad, C. D. 1952. "Determinism, Indeterminism, and Libertarianism". In *Ethics and the History of Philosophy*, 195–217. London: Routledge.

Chisholm, R. 1966. "Freedom and Action". In *Freedom and Determinism*, K. Lehrer (ed.), 11–44. New York: Random House.

Clarke, R. 2003. *Libertarian Accounts of Free Will*. Oxford: Oxford University Press.

Dancy, J. 2000. *Practical Reality*. Oxford: Oxford University Press.

Dancy, J. 2004. *Ethics Without Principles*. Oxford: Oxford University Press.

Davidson, D. 1980. *Essays on Actions and Events*. Oxford: Oxford University Press.

Descartes, R. 1988. *Selected Philosophical Writings*, J. Cottingham *et al.* (trans. and ed.). Cambridge: Cambridge University Press.

Fischer, J. & M. Ravizza 1998. *Responsibility and Control*. Cambridge: Cambridge University Press.

Frankfurt, H. 1969. "Alternate Possibilities and Moral Responsibility". *Journal of Philosophy* 66, 829–39.

Frankfurt, H. 1978. "The Problem of Action". *American Philosophical Quarterly* 15, 157–62.

Harré, R. & E. Madden 1975. *Causal Powers*. Oxford: Blackwell.

Hegel, G. 1969. *Hegel's Science of Logic*, A. V. Miller (trans.). London: Allen and Unwin.

Hornsby, J. 1980. *Actions*. London: Routledge.

Hume, D. 1975. *A Treatise of Human Nature*, L. A. Selby-Bigge (ed.), P. H. Nidditch (rev.). Oxford: Oxford University Press.

Hume, D. 1975. *Enquiries Concerning Human Understanding and the Principles of Morals*, L. A. Selby-Bigge (ed.), P. H. Nidditch (rev.). Oxford: Oxford University Press.

Hume, D. 1985. *Essays, Moral, Political and Literary*, E. F. Miller (ed.). Indianapolis, IN: Indianapolis Liberty Classics.

Hursthouse, R. 1991. "Arational Action". *Journal of Philosophy* 88, 57–68.

Hyman, J. 2001. "-ings and -ers". *Ratio* 14, 298–317.

Kant, I. 1961. *The Moral Law: Groundwork of the Metaphysics of Morals*, H. J. Paton (trans. and ed.). London: Hutchinson.

Kavka, G. 1983. "The Toxin Puzzle". *Analysis* 43, 33–6.

Kenny, A. 1966. "Practical Inference". *Analysis* 26, 65–75.

Lyotard, F. 1984. *The Postmodern Condition*. Manchester: Manchester University Press.

McCulloch, G. 1995. *The Mind and its World*. London: Routledge.

McFee, G. 2000. *Free Will*. Chesham: Acumen.

Martin, C. B. 1994. "Dispositions and Conditionals". *Philosophical Quarterly* 44, 1–8.

Melden, A. 1961. *Free Action*. London: Routledge.

Mele, A. 1992. *Springs of Action*. Oxford: Oxford University Press.

Mele, A. 2003, *Motivation and Agency*, Oxford: Oxford University Press.

Mumford, S. 1998. *Dispositions*. Oxford: Oxford University Press.

O'Connor, T. 2000. *Persons and Causes: the Metaphysics of Free Will*. Oxford: Oxford University Press.

O'Shaughnessy, B. 1980. *The Will*. Cambridge: Cambridge University Press.

Pears, D. 1975. "Sketch for a Causal Theory of Wanting and Doing". In *Questions in the Philosophy of Mind*, 97–141. London: Duckworth.

Piaget, J. 1997 [1929]. *The Child's Conception of the World*. London: Routledge.

Plato 2002. *Protagoras*, C. C. W. Taylor (trans.). Oxford: Oxford University Press.

Reid, T. 1985. *Inquiry and Essays*, R. E. Beanblossom & K. Lehrer (eds). Indianapolis, IN: Hackett.

Russell, B. 1903. *The Principles of Mathematics*. Cambridge: Cambridge University Press.

Ryle, G. 1949. *The Concept of Mind*. London: Hutchinson.

Sober, E. 1984. *The Nature of Selection*. Cambridge, MA: MIT Press.

Stout, R. 2004. "Internalising Practical Reasons". *Proceedings of the Aristotelian Society* 44, 229–43.

Stoutland, F. 1970. "The Logical Connection Argument". *American Philosophical Quarterly* 7, monograph no. 4, 117–29.

Taylor, R. 1966. *Action and Purpose*. Englewood Cliffs, NJ: Prentice Hall.

Thalberg, I. 1967. "Do we Cause our own Actions?". *Analysis* 27, 196–201.

Thalberg, I. 1984. "Do our Intentions Cause our Intentional Actions?". *American Philosophical Quarterly* 21, 249–60.

Williams, B. 1981. *Moral Luck*. Cambridge: Cambridge University Press.

von Wright, G. 1971. *Explanation and Understanding*. London: Routledge.

Index